IMAGES
of America

CROWLEY

Dan,
all the best, neighbor,
Enjoy this look at
what I now call
"home" —
God bless,

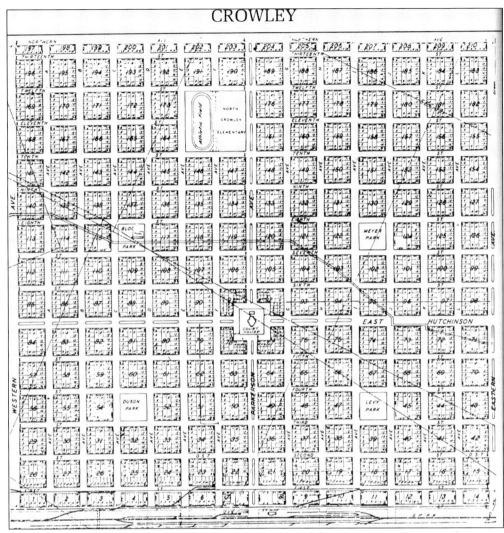

This map shows the one-square-mile grid of Crowley, bounded by Eastern, Northern, and Western Avenues and the Southern Pacific Railroad. Radiating from the center square, the location of the courthouse, are Parkerson and Hutchinson Avenues. Parkerson Avenue, named for the general manager of the Louisiana Western Railroad, runs north and south, while Hutchinson Avenue, named for the general manager of the Southern Pacific Railroad, runs east and west. (Courtesy of Dorothy McNeely.)

ON THE COVER: Keller's Café began as a coffee and sandwich stand about 1925. A new brick building was constructed in 1927 at 122 North Parkerson Avenue. Relocated to 206 West Second Street in 1949, the restaurant closed around 1958. Proprietor Rudolph Keller (1887–1965), pictured in the doorway, was known as "Crowley's Santa Claus" because for many years he played that role at civic and church functions. (Courtesy of Freeland Archives.)

IMAGES
of America
CROWLEY

Ann Mire

Copyright © 2014 by Ann Mire
ISBN 978-1-4671-1229-1

Published by Arcadia Publishing
Charleston, South Carolina

Printed in the United States of America

Library of Congress Control Number: 2014945502

For all general information, please contact Arcadia Publishing:
Telephone 843-853-2070
Fax 843-853-0044
E-mail sales@arcadiapublishing.com
For customer service and orders:
Toll-Free 1-888-313-2665

Visit us on the Internet at www.arcadiapublishing.com

This book is lovingly dedicated to my family and friends and to the people of Crowley, who have welcomed me into their town, homes, and hearts.

Contents

Acknowledgments — 6

Introduction — 7

1. Pioneers and Street Scenes — 9
2. Church and Government Buildings — 15
3. Schools — 29
4. Rice Industry — 33
5. Businesses — 45
6. Residences — 79
7. People — 91
8. Sports — 105
9. Miscellaneous — 111

Acknowledgments

Much of Crowley's history was preserved by Rev. Paul B. Freeland. Among these archival materials are many photographs. The Freeland Archives are housed in the Acadia Parish Library in Crowley, Louisiana. Among those who contributed to the further organization of the archives are Dorothy B. McNeely and members of the Point de l'Eglise: Acadia Genealogical and Historical Society.

Crowley's history has been recorded in Dorothy McNeely's *Crowley: The First Hundred Years, 1887–1987* as well as *Acadia Parish, Louisiana: A History to 1900* by Mary Alice Fontenot and Rev. Paul B. Freeland, and *Acadia Parish, Louisiana: A History to 1920, Volume II* by Mary Alice Fontenot. Many early Crowley photographs were published in *A Pictorial History of Crowley, Louisiana*, by the *Crowley Post-Signal*. L.A. Williams's *Sidewalk Talks* contains valuable information on the history of Crowley's businesses, residences, and pioneers.

Most of the photographs within the collection were taken by B.A. Barnett. Other photographs were taken by early Crowley photographers George Bellar and E.K. Studervant, as well as the staff of Crowley newspapers, including the *Daily Signal*, *Crowley Signal*, *Crowley Post Herald*, and the *Crowley Post-Signal*. Unless otherwise noted, all images appear courtesy of Freeland Archives, Acadia Parish Library.

For assistance in choosing photographs, I express my heartfelt appreciation to Florette Bergeron, Lee Lawrence, and Amy Thibodeaux. An extra thanks to Amy for formatting the photographs. For his invaluable assistance in preparing the chapter on the rice industry, I thank Dr. Tim Croughan. A big thank-you is extended to Karen Welch for her invaluable assistance in researching information on Crowley businesses and residences. Thanks to Amanda Meyer for help with research. I am most grateful to Dr. Richard Bier, who took the time to read the manuscript.

I acknowledge and thank all those who have provided photographs from their private collections. I am grateful to all who helped in the identification of people in the photographs.

Last, but certainly not least, I am grateful to Ted Landry, Acadia Parish Library director, for his support and encouragement in this project. I am also thankful to each member of the Crowley Library staff for their support.

INTRODUCTION

Picture the high grasses of prairie land as the first trains crossed southwest Louisiana in 1881. While most passengers saw a barren wasteland, one man dreamt of building a city there. With several businessmen from Opelousas, W.W. Duson organized the Southwestern Louisiana Land Company in July 1886. Along with his brother C.C. "Curley" Duson, the stockholders included Alphonse Levy, Julius Meyer, Joseph Bloch, G.W. Hudspeth, and Henry Garland. Their first action was to purchase 174 acres of what would become the center of Crowley at the price of 45¢ an acre.

The designer of the grid plan for the town was St. Landry Parish surveyor Leon Fremaux. Over 100 young men cleared the high grasses and brush as the land was surveyed and the streets were marked off. Pulled by eight oxen, a grader driven by Thomas J. Toler and Curley Duson marked the blocks with 16 lots each. A square in the center would be the site for a courthouse, as Crowley was chosen as the seat for the newly formed Acadia Parish in 1886. South Crowley would be laid out in 1897, followed by an auction of many lots.

With "his town" cleared off and laid out, Duson had his real estate office moved by oxcart from Rayne to Crowley. The question of naming the town then had to be resolved. "Crowley's Switch," a house depot managed by road master Patrick Crowley, was located seven miles west of the townsite. Persuaded by Duson, the railroad company moved the depot on flatcars to the new townsite. In exchange, the newly formed town was named Crowley.

Not only were supplies brought to the townsite by rail, but also the first store, which was run by Jac Frankel. He operated it out of a freight car until his store building was constructed. The store's opening day, January 4, 1887, is considered the birthday of Crowley. By the end of that month, Crowley could also boast a schoolhouse, a storehouse, a livery stable, the Southern Pacific depot, and the Crowley House.

Purchasing the *Rayne Signal* newspaper, Duson renamed it the *Crowley Signal* and moved it to Crowley. Then he began a concerted effort to encourage families from the North and Midwest to immigrate to Crowley. Using special advertising in the newspapers of those regions, he touted not only the climate and agricultural opportunities, but also the schools and churches that were being built in Crowley. Furthermore, railroad excursions from those states to Louisiana often included a stop in Crowley.

The Southwestern Louisiana Land Company was responsible for building the first storehouse, hotel (Crowley House), livery stable, and schoolhouse. Interestingly, during the greatest period of business construction, from 1899 to 1903, many of the old structures were moved into the middle of Parkerson Avenue so that business could continue to be conducted as new buildings were erected. When fruit dealer Chris Memtsas's building was removed from the street in February 1903, an unobstructed view from the depot to the courthouse was the result.

Early pioneers grew what was known as providence rice. Planted in shallow ponds, the crop depended upon the "divine providence" of rainfall for its success. However, as a canal and irrigation system began to be developed through the efforts of the Abbott brothers and the Freeland brothers,

there was more certainty in raising a good crop. With the arrival of Salmon "Sol" Wright in 1890 and his development of a better rice grain, as well as the proliferation of rice mills, the area became known for its rice industry.

With the recognition of rice's value, rice carnivals were held in 1927 and 1928 to celebrate the role of the industry. In conjunction with the celebration of Crowley's 50th birthday in 1937, a rice festival was held. That tradition, suspended during the World War II years, has continued to the present. Rice-farming families are recognized for their contributions. Agriculture remains a vital part of the economy, and it now includes crawfish farming.

Today, visitors to Crowley witness a wonderful blend of the past and the present. Many old residences remain in the city's historic district. Downtown Crowley is a mixture of new and old businesses. Many old buildings, such as the Grand Opera House, Crowley Motor Company, the Rice and Acadia Theatres, First National Bank, Egan Hotel, and Duson Building, remain standing and functional.

Throughout its history, Crowley has been served by many civic-minded citizens. The following men and one woman have served as Crowley's mayors: Dr. Derrick P. January (1888), James Stewart (1888–1889), Arsemus Burkdoll (1889), Gustave Fontenot (1890–1892), Derrick R. January (1892–1894), Philip Chappuis (1894–1898, 1902–1906), James Barry (1898–1900), William Campbell (1900–1902), Shelby Taylor (1906–1909), Dallas Hayes (1909–1910), Michael Egan (1910–1920), Philip Pugh (1920–1928), Gordon Brunson (1928–1930), Clifton Smith (1930–1931), Noble Chambers (1931–1934), James Madison "Matt" Buatt (1934–1950), Harold Lyons Sr. (1950–1954), Joseph Gielen (1954–1978), Robert Istre (1978–1997), Joseph Webb Jr. (1997), Isabella delaHoussaye (1997–2007), and Greg Jones (2007–present).

Prior to the election of its first chief of police, the Acadia Parish Sheriff's Office was in charge of law enforcement for the city. Crowley's chiefs of police have included James Lyons (1900–1906), Milton Wilkins (1906–1910), William Burt (1910–1918), Felix Lina (1918–1922), Boyd Milton (1922–1930), Gus Wilkins (1930–1946), Maxwell Barousse (1946–1967), John "Al" Gibson (1967–1974, 1978–1987), Allen Castille (1974–1978), Harry Courville Sr. (1987–1995), Donald Alleman (1995–2003), and K.P. Gibson (2003–present).

Acadia's sheriffs have included Eldridge Lyons (1887–1889, 1892–1900), William Chevis (1889–1892), Joseph Murrell (1900–1908), Louis Fontenot (1908–1928), Walter Larcade (1928–1960), Elton Arceneaux (1960–1984), Kenneth Goss (1984–2004), and Wayne Melancon (2004–present).

In its early years, Crowley was served by a volunteer fire department. Its fire chiefs included Matthew S. Little (1903–1904), John Mallett (1904–1908), Gilbert Miles (1908–1910), Gilbert's brother John Wesley Miles (1910–1948), John Andrus (1948–1975), John LeLeux (1975–1999), Russell Meche (1999–2003), William Schmaltz (2003–2005), John Christman (interim, one month, 2005), and Jody Viator (2005–present).

Those who have served as Crowley city judge are Dallas B. Hayes (1904–1908), William P. Campbell (1908–1912), Denis Timothy Canan Jr. (1912–1950), Edmund M. Reggie (1950–1976), Don Aaron Jr. (1976–1982), Barrett Harrington (1983–2008), and Marie Elise Trahan (2008–present).

The census figures for the number of persons in Crowley are as follows:

1890—240	1960—15,617
1900—4,214	1970—16,104
1910—5,099	1980—16,036
1920—6,108	1990—13,983
1930—7,656	2000—14,225
1940—9,523	2010—13,265
1950—12,784	

One
PIONEERS AND STREET SCENES

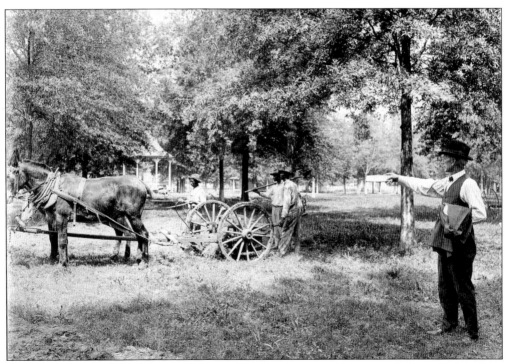

Crowley cofounder W.W. Duson was devoted to the progress of his town. In Levy Park in May 1920, Duson (far right) directs, from left to right, Mr. Basile, Jules David, and Mr. Carmouche. His workers often helped clean Crowley's parks and church and school grounds. At Crowley's founding in 1887, four parks were donated and named for Southwestern Louisiana Land Company stockholders: Alphonse Levy, Julius Meyer, Joseph Bloch, and the Duson brothers.

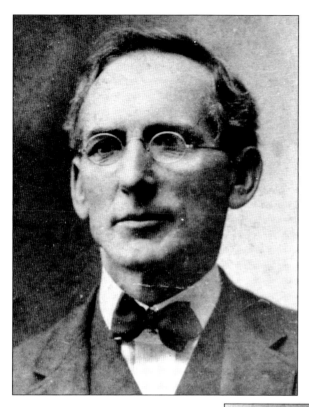

W.W. Duson (1853–1929) was born in St. Landry Parish. He managed a mercantile store at Plaquemine Brulee. With his brother C.C., he founded the town of Crowley and became its biggest booster. His business enterprises included large rice farms, irrigation canals, and the oil and mineral industry. His spouses were Anna McClelland (1860–1881), Julia Clark (1866–1892), and Clara Thayer (1872–1974). His children were Mamie, Henry, Maxwell, William Jr., Marguerite, and Mildred.

C.C. "Curley" Duson (1846–1910) was born in St. Landry Parish. He served in many government positions, including St. Landry deputy sheriff (1867–1872) and sheriff (1873–1887), and Louisiana state senator (1888–1892). He moved to Crowley in 1892 and helped found other nearby towns. His spouses were Isora Andrus and Eunice Pharr and his children were Morton, Walter, Rodney, Clayton, Jesse, Lola, George, Meta, Curley P., and William.

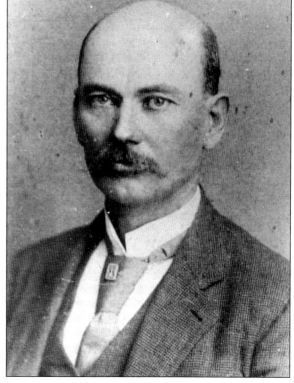

Leon Fremaux (1847–1890), a civil engineer, did much surveying in the territory around Mermentau, where he settled with his wife, Irene Murr (1851–1924) in 1875. They later moved to Plaquemine Brulee, near Branch. Associated with W.W. Duson, Fremaux drew the grid for the city of Crowley, considered a well-laid-out city.

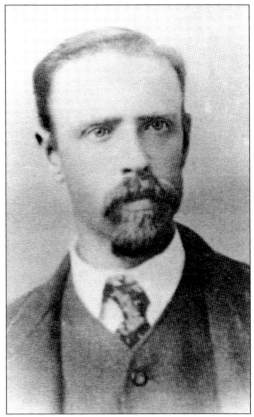

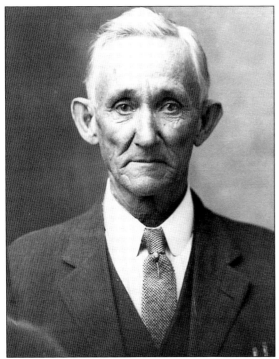

Dan B. Smith (1857–1941) claimed to be the earliest settler of Crowley. He came to Rayne from Mississippi in 1885 when he read W.W. Duson's advertisement touting opportunities in the area. Upon his arrival, Smith helped Fremaux survey Crowley. He staked off the streets and pulled the first chain grader over high grasses, using four yokes of oxen. His spouse was Bessie (1869–1959).

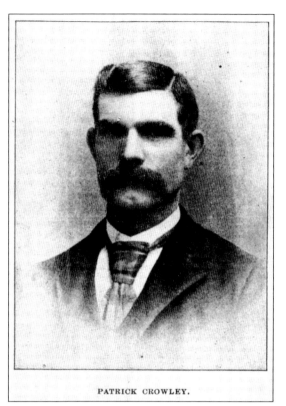

PATRICK CROWLEY.

Patrick Crowley (1830–1909), born in Ireland, came to Louisiana as railroad construction expanded. While working for Southern Pacific, he had a spur track and a house depot, which Duson persuaded him to move to the location of "his" town in return for its being named for him. Although he never lived in Crowley, he did own some property. Described as a typical Irishman, he had a quick wit.

Jac Frankel (1859–1941), born in Poland, came to America and settled in Opelousas with relatives. Coming to Crowley upon its founding in 1887, he was the town's first storekeeper, first postmaster, and the organizer/president of the Bank of Acadia. Among his civic duties, Frankel served as treasurer for the police jury and the school board and as a member of Crowley's first city council. He and his wife, Emma Loeb (1866–1922), had three daughters: Jeanette, Elise, and Mildred.

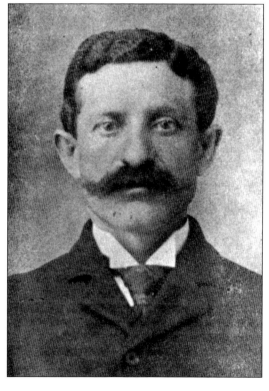

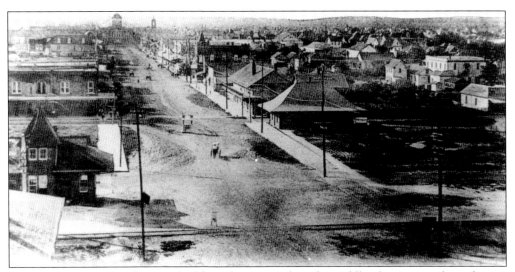

Parkerson Avenue, seen here in 1905, has a horse trough in the middle of street, matching the one at the courthouse. The Wells Fargo depot and the Crowley House are visible along the right side of the street. At left are the Southern Pacific depot and a boardinghouse. Crowley's population at the time was 5,000 people. The city had recently added concrete sidewalks.

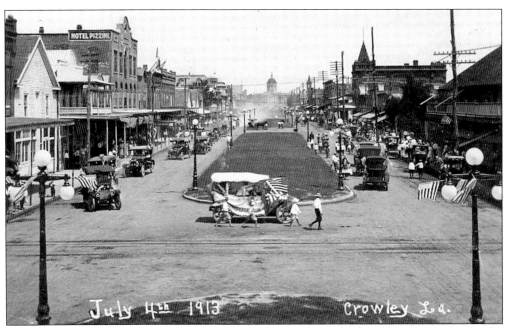

Parkerson Avenue, with its new hard surface of creosoted wooden blocks, is shown during the Fourth of July parade in 1913. In its early years, Crowley celebrated the Fourth of July with speeches, picnics at the fairgrounds, and parades. Crowley citizens decorated their vehicles and joined in the holiday parade.

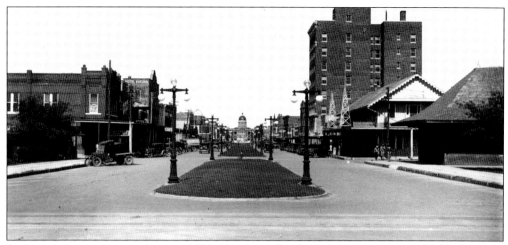

Parkerson Avenue is seen here in 1930. On the right, from front to rear, are the Wells Fargo Depot, the Crowley House, and the First National Bank. Recognizable on the left are the Signal Building and Hotel Lyons. The second courthouse is visible at the end of the street. Crowley's population in 1930 was 7,600.

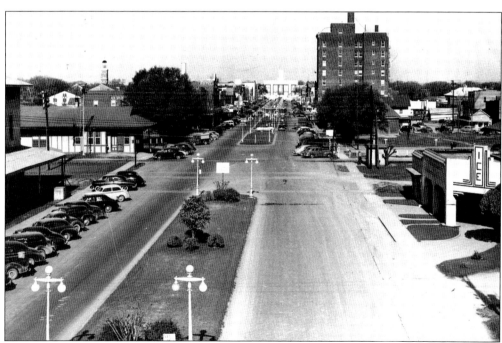

This photograph of Parkerson Avenue in 1952 shows the Crowley Ice Factory in the foreground at right and, farther down, the First National Bank. The Southern Pacific freight depot is at center left, and the third courthouse is in the distance. Also in the distance, at far left, is the St. Michael's Church steeple. The town's population at the time was 12,700.

Two

CHURCH AND GOVERNMENT BUILDINGS

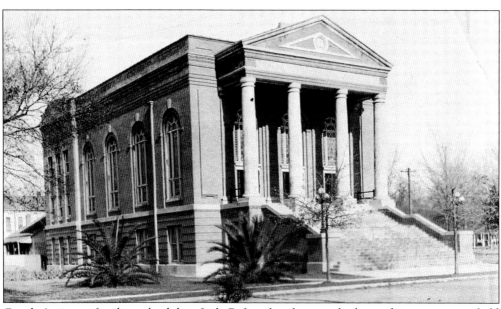

Crowley's pioneer families valued their faith. Before churches were built, worship services were held in school buildings and in a special "chapel" room at the Crowley House, the town's first hotel. The second United Methodist Church building (shown here) was constructed by Montague Brothers in 1913. The Greek Revival structure featured stained-glass windows made in Germany. While major repairs were being done in 1948, churchgoers worshipped at the nearby Presbyterian church.

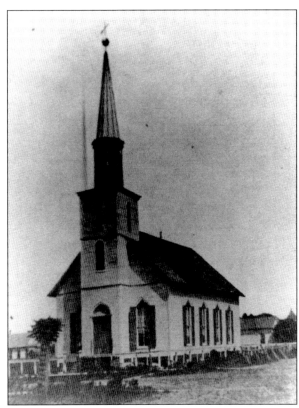

With services held as early as 1887, the Methodist Episcopal Church South was the first organized church in Crowley. Located at the corner of North Avenue I and East Third Street, on land donated by W.W. Duson, the first church building was completed in 1889. In use until 1913, it was replaced by a new building (see page 15), still functioning today.

The First Presbyterian Church was organized by seven members in 1890. This November 1929 photograph shows the wood frame church (right), built in 1896, partially moved into the street while the Gothic brick church was being built. The financial contributions of church members T.B. and C.J. Freeland Sr. aided in the construction.

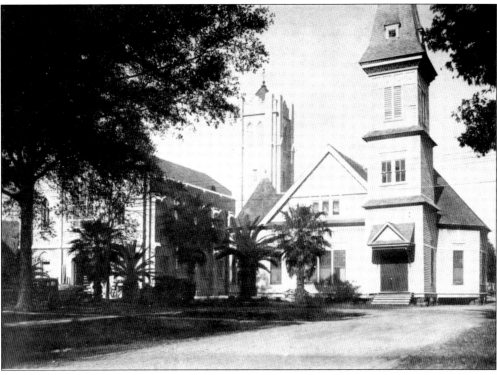

In 1893, a dozen German Lutheran families held the first Lutheran service in the "chapel" room of the Crowley House. Contractor Theodore Schaedel built the first church (above) in 1895 on land donated by W.W. Duson. Early services were conducted in both German and English. Located at the intersection of North Avenue F and West Eighth Street, the original building was remodeled and enlarged in 1940 shortly before the flood in August of that year. Water damage forced much of the work to be redone. The original altar remains in the church. An unsuccessful attempt to lift and pivot the church so that it faced Avenue F took place in 1989 (at right); however, the building was successfully leveled at that time. (At right, courtesy of Crowley Post-Signal.)

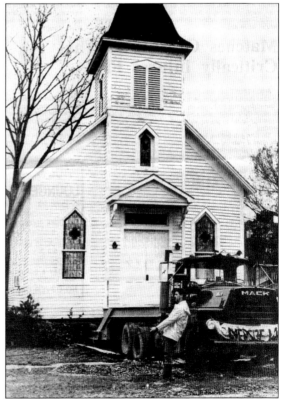

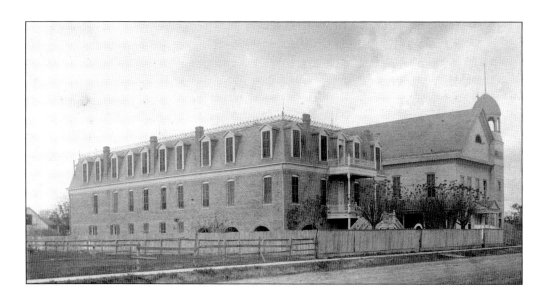

The 1903 photograph above shows St. Michael's Catholic Church (right) and the Convent of Perpetual Adoration. The original wood frame church, built in 1892 by contractor Theodore Schaedel, was located at the northeast corner of North Avenue H and Eighth Street. When it was moved in 1899 to the corner of Avenue F and West Hutchinson Avenue, a second story was added to accommodate a school. The convent, with a mansard roof, was constructed by local contractor James Petty in 1902. The photograph below shows the new church (left), designed in Italian Renaissance style by architect Theodore Brune and built in 1912. The church's dome, dismantled in 1951, had a diameter of 30 feet and was fixed 85 feet above the ground.

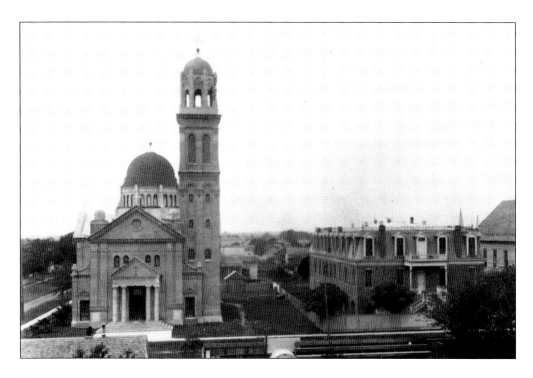

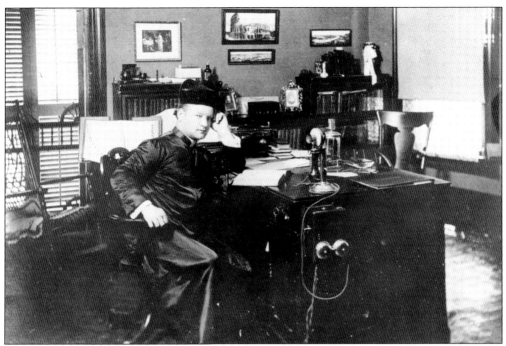

Fr. A.F. Isenberg, seen here in his study in December 1917, served as pastor of St. Michael's Catholic Church from 1909 to 1929. Under his pastorate, a new church was erected and dedicated on May 9, 1912. The building committee overseeing the project consisted of Philip Chappuis, Joseph Medlenka, T. Simon, Ovignac Dore, A. Melancon, and Edgar L. Vinet. Father Isenberg left Crowley to become pastor of St. John's Cathedral in Lafayette.

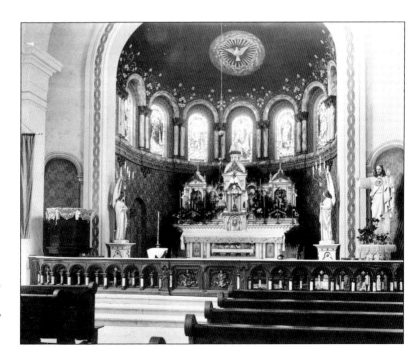

An interior view of St. Michael's Catholic Church shows the altar. The brick church, constructed and dedicated in 1912, had a seating capacity of 800.

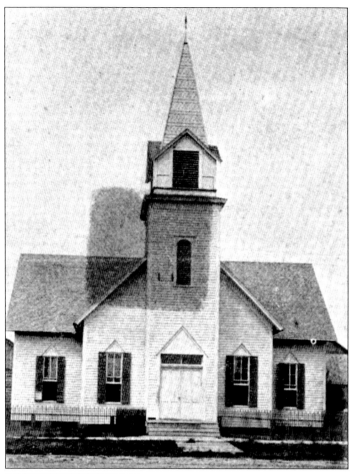

The First Baptist Church, organized in 1889 by Rev. T.B. Harrell, dedicated its first building, at left, in 1892. It was located on Avenue G between East Fifth and Fourth Streets. Prior to the construction of the church, services were held in the "chapel" room of the Crowley House. When the lot was sold to Champion Iron Works Company, the church building was moved down the block to the opposite corner, where three lots had been purchased. Construction on the current church building on East Fourth Street began in 1945, and the first service was held there in 1947. Below, the Baptist church's Sunday school classes pose in 1897.

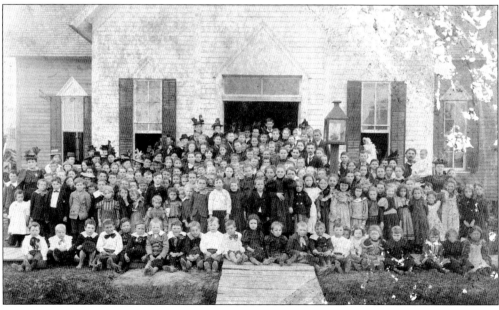

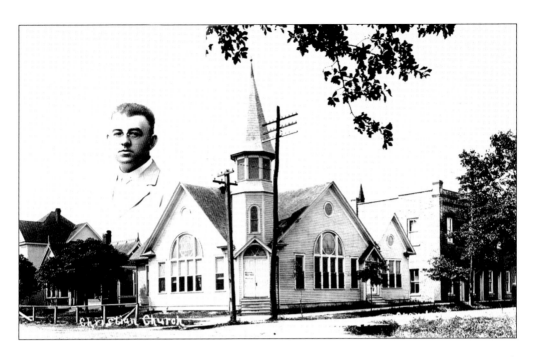

The First Christian Church and Rev. Fred Ross are pictured above in 1914 on a unique card. Constructed in 1902 at the corner of East Hutchinson Avenue and North Avenue G, this church was used until 1957, when a new church was built on West Fourteenth Street. The photograph below shows a Sunday school picnic in 1903. Discovered among the church's files that were to be discarded, the image was given to Dorsey Martin and shown to Rev. Paul Freeland, who preserved it in 1966. Purchased by the Central Church of Christ, the old building was used until 1973. Vacant, it was severely damaged by the tornado of October 29, 1974, and it was demolished in 1975.

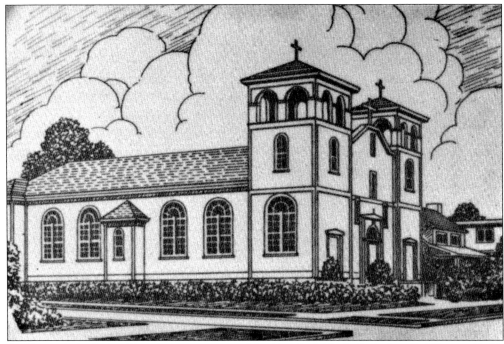

St. Theresa's Catholic Church was constructed for Crowley's black Catholics. Fr. Thomas Duffy of the Josephite Order arrived in Crowley in 1920 to work with St. Michael's pastor, Fr. A.F. Isenberg, to create a parish church for African Americans. The Church Hall was built first, and it was used for church services and as a school until the church building was completed in 1922 with the assistance of many volunteers. The school, under the guidance of the Sisters of the Holy Ghost, functioned until 1991. The church, located on West Third Street, is seen above in a 1920s sketch. Below, the congregation gathers in front of the church and rectory around 1922. The pastor may have been Rev. H.A. Gilman, and the three nuns may have been the first to arrive: Sisters M. Columba, M. Justiniana, and M. Aquinas.

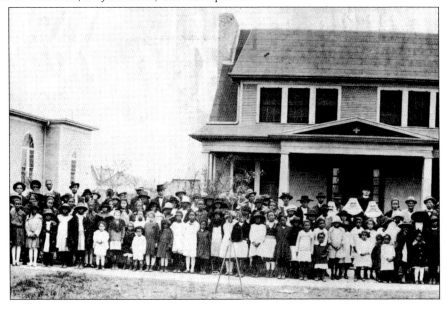

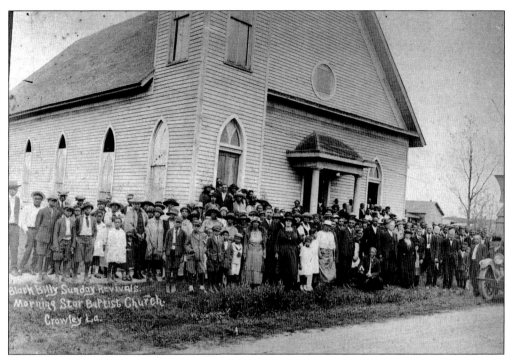

Morning Star Baptist Church, the first congregation for African Americans in Crowley, was organized in 1889 by Rev. Joseph Barker. This church was built in 1892 on land donated by W.W. Duson on West Third Street. Henry Clay Ross, seen standing behind the squatted gentleman in front, served as pastor from 1910 to 1945. The other identified person is Wilhemina Ennis, a Crowley teacher, standing to the right of Ross. (Courtesy of Dorothy Freddie.)

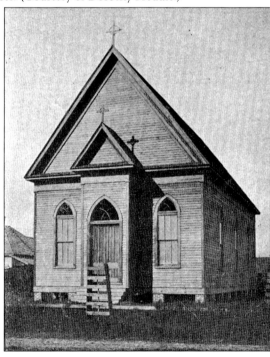

Trinity Episcopal Church was organized in 1893. Contractor James Petty constructed the first church on lots donated by W.W. Duson and George Bradford on the northeast corner of Parkerson Avenue and Court Circle. Reverends W.S. Slack and F. Boberg conducted the first services in 1900. Acadia Savings & Loan Association purchased the site in 1967, and the Episcopalians moved into a new church at the corner of Hoffpauir Street and Northern Avenue in 1969.

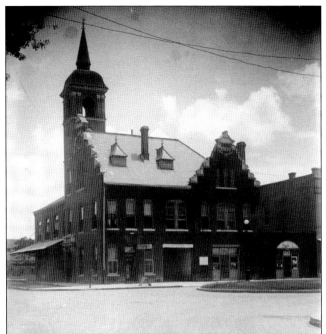

This photograph shows Crowley's first city hall (1900–1932). Prior to its construction, city officials met in the mayor's business office or at the courthouse. The project was completed by architect Henry Walters and contractor M.L. Lewman. Besides rooms for elected officials, the building included a marketplace, a fire station, and an auditorium. It served as home of Acadia Post No. 15 of the American Legion from 1946 to 1981. Renovated in 2011, it houses a restaurant.

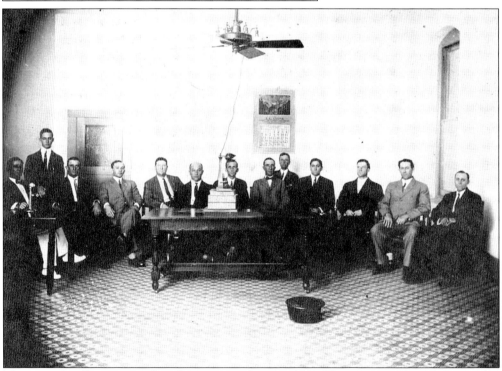

The mayor's office, on the first floor, is seen here in 1913. The men are, from left to right, Rudolph Boudreaux, city clerk; Clarence Boudreaux, Rudolph's son and assistant; Rufus Hoffpauir, councilman; Harry Gueno, city attorney; Joseph G. Medlenka and Aaron Loeb, councilmen; Denis Canan Jr., city judge; William M. Egan, mayor; William Burt, chief of police; Wesley Miles, fire chief; and Alphe Melancon, Thomas Barton Freeland, and Edgar Louis Vinet, councilmen.

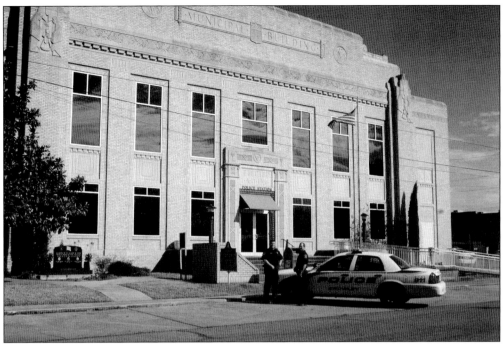

Crowley's second city hall (1932–2006) was designed by architect W.T. Nolan and constructed by Curtis McDaniel. Since 2006, this two-story Art Deco brick building has housed the Crowley Police Department. Sgt. Jeremy Abshire (left) and Lt. Scott Fogleman are shown in front of the municipal building. A memorial plaque honors three officers who died in the line of duty: Patrolmen Ezra Foreman and Anthony Suire and Lt. Richard Newman. (Photograph by Susette Brunson.)

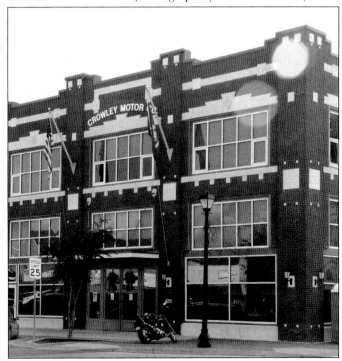

Crowley's third and current city hall since 2006, this three-story brick building originally housed Crowley Motor Company. The building also houses Crowley's City Museum and the J.D. Miller Museum, highlighting Miller's music studio. (Photograph by Mike Dubois.)

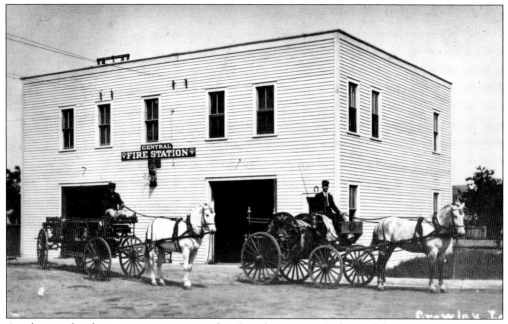

A volunteer fire department was organized in Crowley in 1898. In front of the Central Fire Station, built in 1912, are drivers Jack Fristoe (left) and Joe Domengeaux, with fire horses Rock and Riley. After the death of Rock in 1916, the first fire truck was purchased.

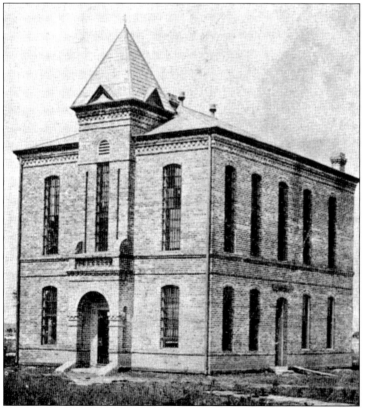

The four Acadia Parish jails, all made of brick, were located on the Court Circle. The original jail was a small, one-story building (1888–1894). Shown here is the second jail, a red-brick building (1894–1926). A three-story facility served as the jail from 1926 to 1962, and the fourth was a two-story building (1962–2007). The current jail was built on the western outskirts of Crowley.

Acadia Parish has had three courthouses, all located on the Court Circle on Parkerson Avenue. Crowley was selected as the parish seat in an election on March 27, 1887. Built on land donated by Duson's Southwest Louisiana Land Company, the first courthouse, at right, was occupied on June 30, 1888. This starkly simple, two-story, buff-colored brick structure was nearly square in design, with a steep hipped roof. Its principal feature was the central tower and dome. It served as the courthouse until 1903. The photograph below shows the interior of the courthouse in 1894. Seated at lower left are Sheriff Elridge Lyons (far left) and Martin Andrus. Seated at upper left is Hampden Story. Addressing the court is attorney Philip Chappuis, with Charles Crippen standing at the far right.

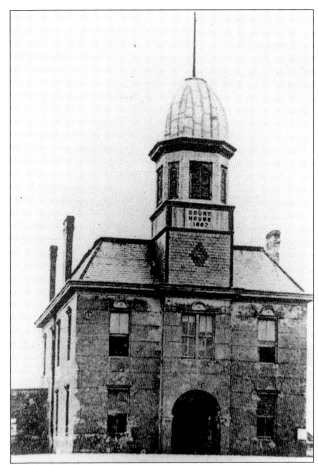

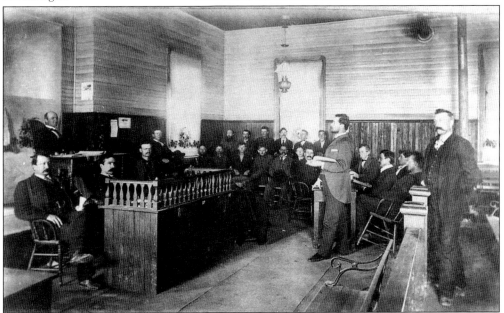

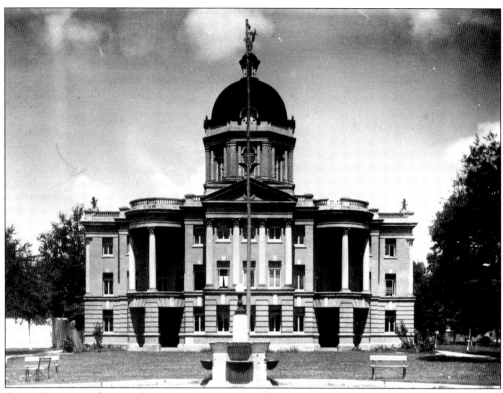

Seen above, Acadia Parish's second courthouse (1903–1951), designed by J. Riley Gordon of Houston and W.L. Stevenson of Crowley, was constructed by T. Lovell. Occupied in September 1903, this elegant brownstone, red-brick building featured a sculptured American eagle atop its triangular gable. (The eagle is now located at Wright Enterprises.) Although repairs were made in 1931, the building's deteriorated condition was worsened by a butane gas explosion in 1936. It was reported that the building was in such "dangerous" condition that it would "part in the middle sooner or later." Over the next decade, patchwork repairs were made. Voters approved a $1 million bond issue for a new courthouse in December 1948. Shown below is the third courthouse (1951–present), built of limestone. It was designed by Theodore Perrier of New Orleans. Builder R.P. Farnsworth of New Orleans completed this Art Deco courthouse.

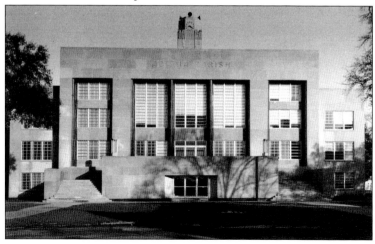

Three
SCHOOLS

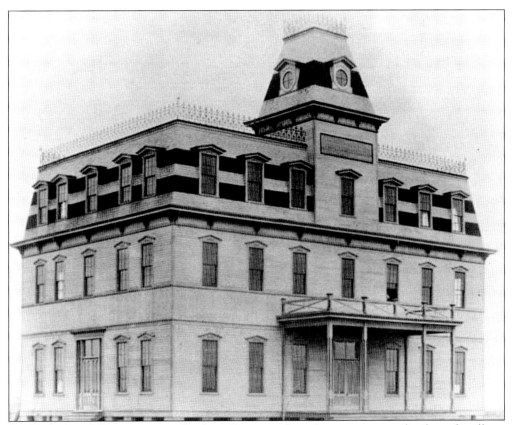

Established in 1889 as a private school to educate students from primary grades through college, Acadia College was constructed on property between Tenth and Twelfth Streets and donated by W.W. Duson. Prior to its construction in 1892, classes were conducted in the Crowley House. The three-story building included boarding facilities for students. Totally destroyed by fire on December 8, 1899, the college was never rebuilt because of financial difficulties.

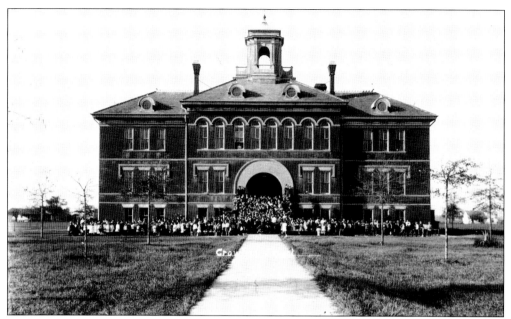

North Crowley School, shown here in 1914, was built in 1902 and demolished in 1939. It was located in the center of the block formerly occupied by Acadia College. It served all grades until 1921, when a second brick building was constructed on the corner of Parkerson Avenue and Twelfth Street. At that time, the original North Crowley School served as an elementary school, while the newer facility served as Crowley High.

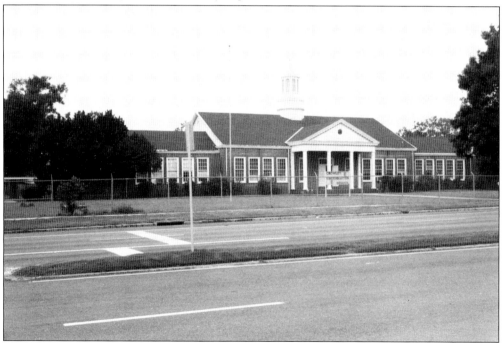

Hawsey Memorial Elementary was built in 1938. It was named for Dr. Henry Hawsey (1875–1937), a local dentist who was a member of the Acadia Parish School Board. It served as an elementary school until 1973, when it became Crowley Kindergarten.

Crowley University School was built by Prof. John Hiram Lewis (1867–1942) on the corner of North Avenue H and Eighth Street. The purpose of this private high school was to prepare students to enter universities or the business world; both boys and girls were admitted. Lewis closed the school in 1906, when he became superintendent of schools for Acadia Parish.

With South Crowley's population growth, the city constructed a new building for students. As early as 1904, South Crowley children were taught in temporary schoolhouses until this facility was completed in 1907. The following year, South Crowley School organized the first parent-teacher organization in Acadia Parish. Located on the same property as the current South Crowley Elementary, the school originally served all grades. It was demolished in 1967.

Opened on October 10, 1939, under the direction of John W. Mitchell, the Southwest Louisiana Vocational-Technical School was located on West Twelfth Street until 1983, when a new facility was built on West Hutchinson Avenue. Operating 24 hours a day during World War II, the school trained thousands for employment in defense plants. Its name was changed to Louisiana Technical College in 1999.

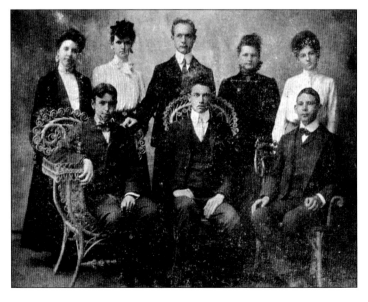

Members of the first graduating class of Crowley High School pose in 1904. They are, from left to right, (first row) Ivan Way, Richard Schultz, and Vernon Haupt; (second row) Rose Wilder, Carrie Naftel, Prof. B.B. Stover, Mary Holt, and Phala Baur. Rose Wilder, the daughter of Almanzo and author Laura Ingalls Wilder, came to Crowley and lived with an aunt, Eliza Jane Wilder Thayer, during her final year of school.

Four

RICE INDUSTRY

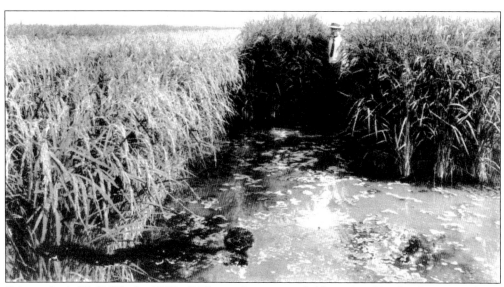

Salmon Lusk "Sol" Wright (1852–1929) stands in a rice field in 1917. His development of new rice varieties, especially the Blue Rose, was instrumental in saving the industry. Beekeeping, his avocation, played a vital role in the successful cross-pollination of rice varieties. Many of Crowley's early parades honored him, including the 1922 Armistice Day parade that featured Wright in a car decorated with the rice varieties he developed.

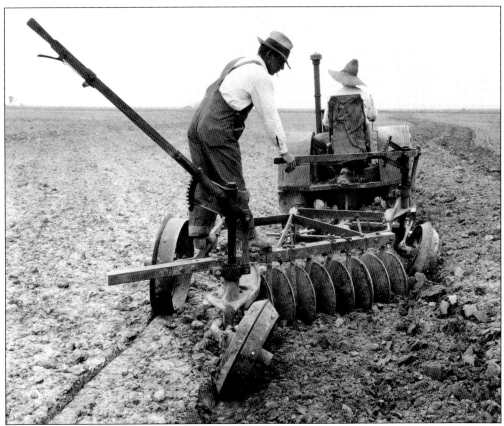

The process of planting and harvesting rice has evolved through the years. After the land is plowed in preparation for the planting of a rice crop, a disc plow, as shown here, would construct a field levee to allow for control of irrigation for the rice crop.

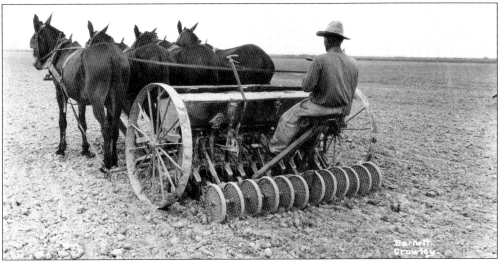

A team of mules pulls a 12-hole grain drill to seed rice in the field. Seed is thinly dropped in the soil into shallow grooves made by the equipment. The equipment then covers the dropped seed with soil, forming evenly spaced rows as it travels through the field.

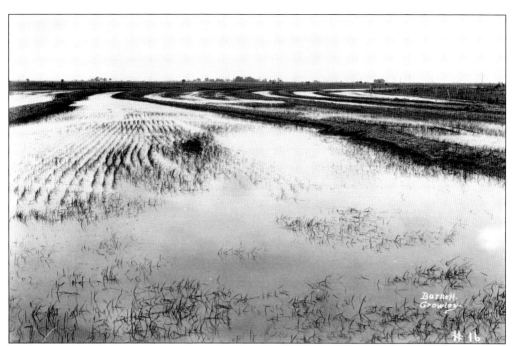

Young rice grows in a field that has been irrigated. Prior to irrigation canals, only so-called Providence rice was grown since it depended solely upon sufficient rainfall by "divine providence." The water also helped with weed control. Planting rice at the lower end of slightly sloped fields was a technique used when growing Providence rice in order to increase the water depth and continuity when relying solely on rainfall for water.

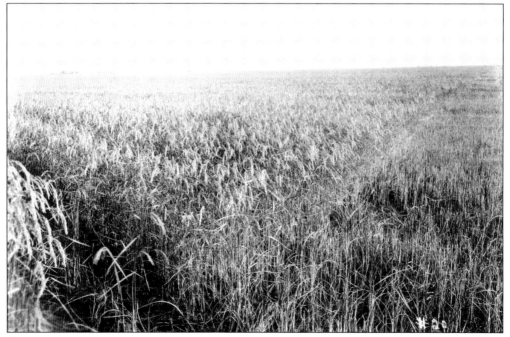

Shown here is mature rice ready to be harvested. Note that the rice forms at the top of the plants. At maturity, the rice is heavy enough so that the tops sag from the weight.

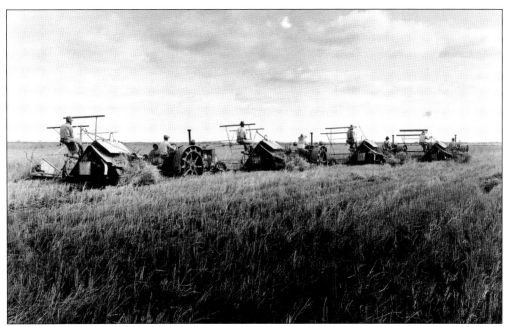
In the early years of rice production, binders were used to cut the rice and tie it into bundles with twine. The bundles of rice were then dropped from the binder as it moved through the field.

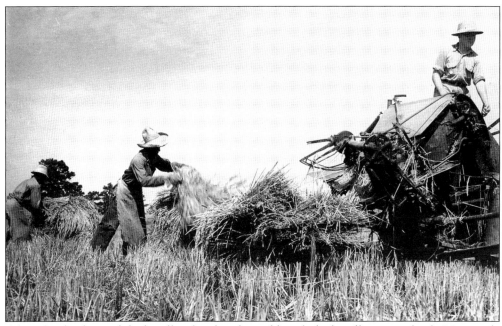
After a binder dropped the bundles, farmhands would stack the bundles into a shock. Many early immigrants to the Crowley area worked on rice farms. (Courtesy of Elaine Wright.)

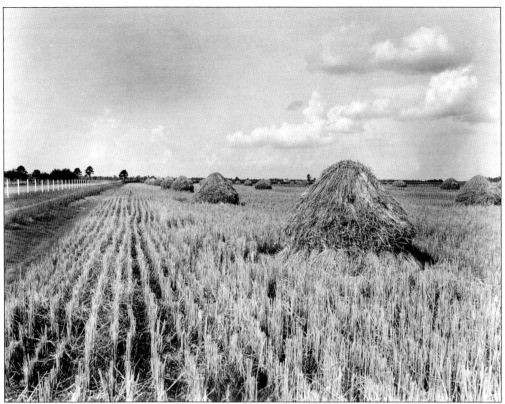

The bundled rice was formed into shocks. The dome-shaped stacks allowed rainfall to roll off the sides. The rice would cure or dry in shocks for up to two weeks to achieve about 12 percent moisture before it was threshed.

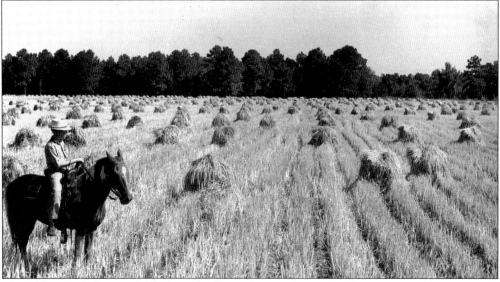

This photograph shows a field of rice shocks on the Wright farm. When it was ready, the bundled rice was picked up and taken to the thresher. The man on horseback is unidentified. (Courtesy of Elaine Wright.)

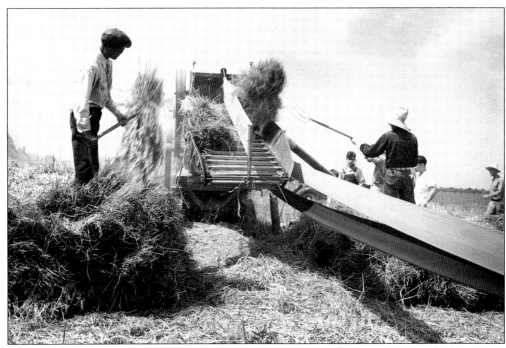

When the rice shocks were dry enough, the bundles were loaded onto a wagon and taken to the threshers. Here, farmhands feed bundles into a thresher. (Courtesy of Elaine Wright.)

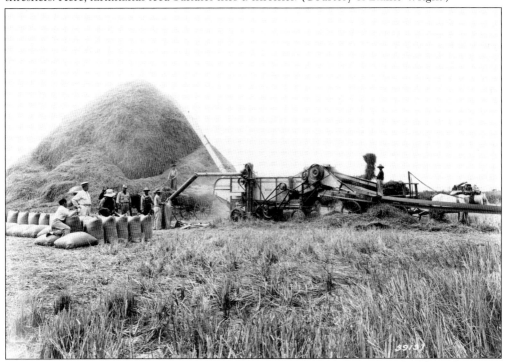

During threshing, as shown here, the rice is separated from the straw and collected in large burlap sacks. Note the large pile of straw at left. Although machines were helpful, much of the work was labor-intensive.

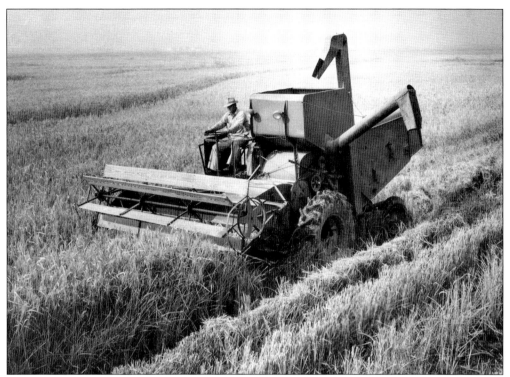

Combines, like the early version seen here in 1949, revolutionized the harvesting of rice. Instead of the two steps of cutting and binding the rice and then threshing it after the rice was dried in the field, a combine was able to accomplish both cutting and threshing in one step with one machine.

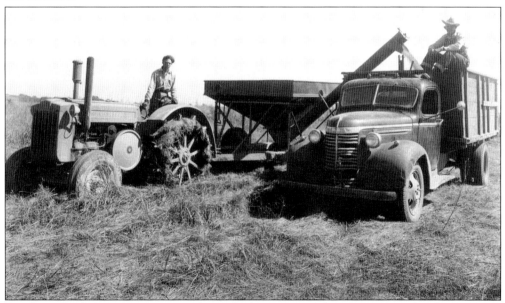

Combines loaded grain onto a cart, from which it was transferred into a truck. The grain was then taken to the rice mill, where it was stored in bins until it was ready to be processed. Today, rice is often stored in bins on the farmer's property before being hauled to mills.

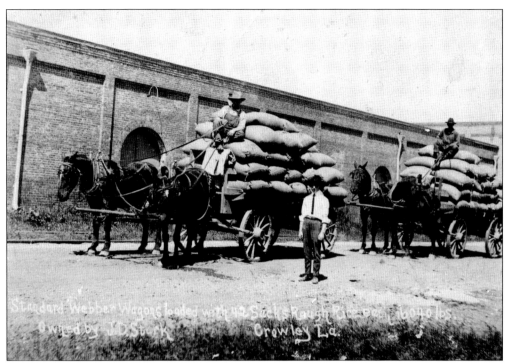

In the early days, mule-drawn wagons took the rice bags to the mills. Here, Standard Webber wagons are loaded with sacked rough rice near one of Crowley's rice warehouses. The warehouses were located near the rice mills, which were along the railroad tracks.

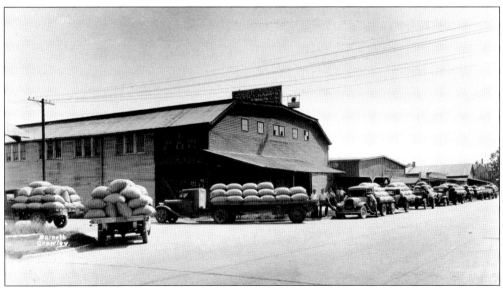

This 1949 photograph shows trucks rather than mule-driven carts delivering rice to the mills. Rough or seed rice was placed in sacks weighing between 180 and 225 pounds. The sacks were then stored within a rough rice warehouse until the rice was ready to be milled. Today, the rice grain is stored in bins on a farmer's property until ready to be shipped to the mills.

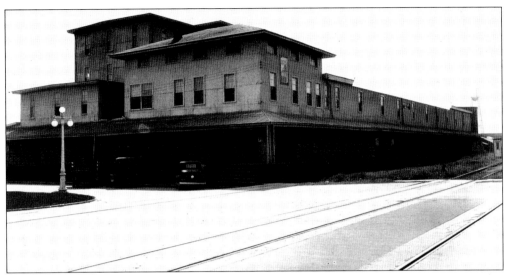

Built about 1896, the People's Independent Mill was one of Abrom Kaplan's enterprises. This landmark facility operated for over 60 consecutive years. Among its early managers was Charles J. Bier in 1900. In 1911, the Louisiana State Milling Company absorbed this establishment. It closed around 1960.

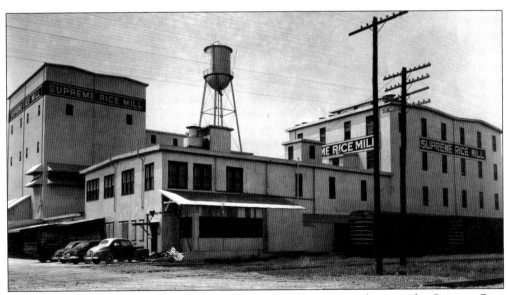

Joseph Dore (1892–1973) purchased the Simon Rice Mill in 1941 and renamed it Supreme Rice Mill. As president, he installed rough-rice bins. This facilitated the handling of rough rice from the farm by utilizing bulk storage of rice in bins at the mill. His son Gordon and grandson Bill continued the family-owned mill until it was acquired by Louisiana Rice Mill in 2008.

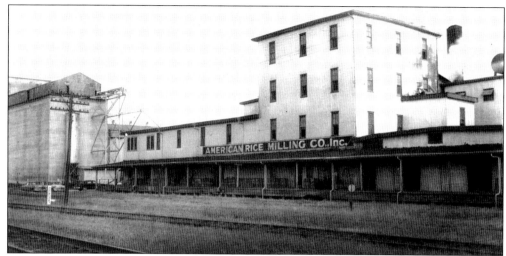

Chartered in 1899, the American Rice Milling Company's first officers were J.J. Thomas, president; J.W. Roller, vice president; and C.J. Freeland Sr., secretary/treasurer. Its original building burned down in 1908. The company closed in the late 1950s. The photograph below shows workers on the clean rice crew in 1949. They are, from left to right, (first row) Curlie McCoy, Wallace Thomas, Wallace Deville, Willie Spriggins, John Marks, Daniel Andrus, John Bernard, Emile Morgan Jr., Edward Alfred, and Arthur Thomas Jr.; (second row) Ernest Capel (standing), Oris Lavigne, Wesley Davis, C.J. Malbrough, Marshall Frank Jr., Oscar Alfred, Houston Edwards, Frank Barker, James Skinner, Mitchell Foote, Joe Fontenot, Morris Dossman, and Floyd Leger (standing); (third row) Leo Ned, Walter Mitchell, Clifton Jack, Ernest Jack, Ben Dossman, Rene Edwards, Harvey Richard, Willie Morgan, Johnny Lee Mitchell, and Holland Castille.

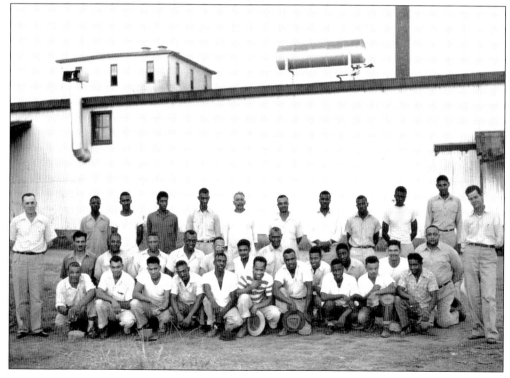

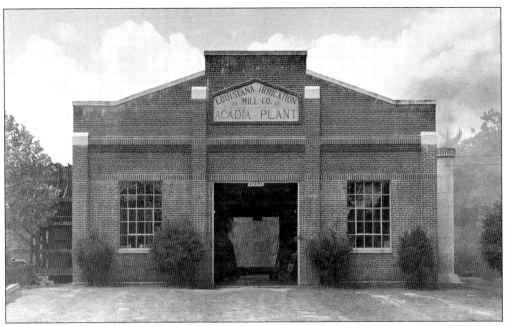

Located at Pointe-aux-Loups Springs, the Acadia Canal Company was one of several irrigating systems that were consolidated with Louisiana Irrigation and Milling Company's organization in 1904. The company's presidents were W.W. Duson (1904–1907), P.L. Lawrence Sr. (1907–1914, 1917–1922), Preston Lovell (1914–1915), Jac Frankel (1915–1917), T.B. Freeland (1922–1940), C.J. Freeland Sr. (1940–1949), Barton Freeland Sr. (1949–1983), Barton Freeland Jr. (1983–1993), and Russell Freeland (1993–). Irrigation operations ceased around 1987. (Courtesy of Russell Freeland.)

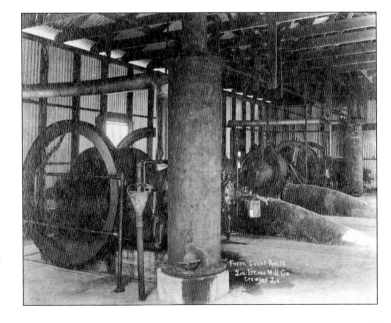

Pumping plants were a vital part of the irrigation and canal system. Plants were located near streams. Flumes were constructed to connect the pumps with the canals and laterals, which led into the rice fields. Depending on water levels, a relift station was often necessary to pump water from a lower level to a higher canal. The Ferre Relift station is seen here in 1903. (Courtesy of Russell Freeland.)

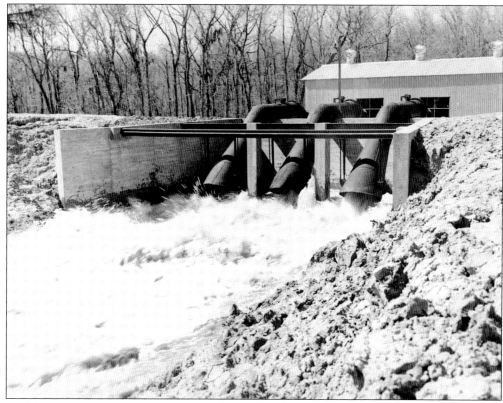

At this pumping station, water is pumped along miles of canals that will eventually irrigate the rice fields. Canals extended in crisscross fashion through rice fields. (Courtesy of Russell Freeland.)

Established in 1909, the Crowley Rice Experiment Station was a joint project of Louisiana State University and the US Department of Agriculture. Under the leadership of its early superintendents, Friend B. Quereau (1909–1916) and Mitchell Jenkins (1917–1946), its value to the rice industry was assured. From its initial 60 acres, the site has grown to over 1,000 acres. Since 2002, Steven Linscombe has been the director. The station is seen here in 1913.

Five

BUSINESSES

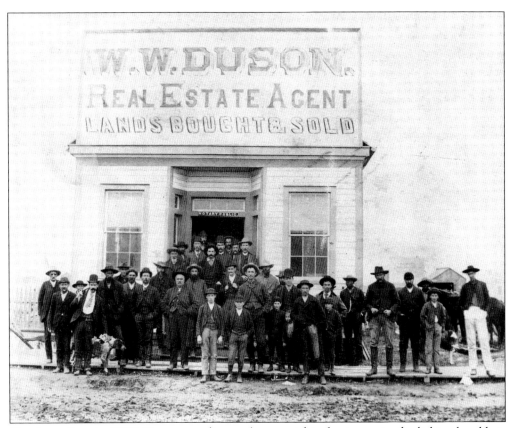

Crowley cofounder W.W. Duson, standing at the rear right of entrance in the light-colored hat, established a real estate business that was responsible for the majority of properties handled in the town's early years. Taken by George Bellar in 1892, this photograph shows Duson's first office, on the southwest corner of North Parkerson Avenue and Second Street. It remained at this location until 1900.

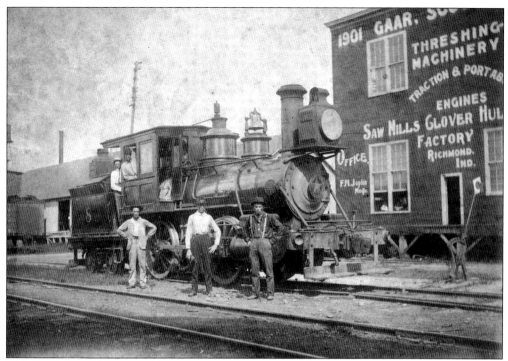

Garr, Scott & Company of Richmond, Indiana, manufacturers of tractors, threshers, and sawmill machinery, established a Crowley branch in 1899. It was in business until at least 1909. Manager F.M. Joplin (1847–1921) operated Crowley's warehouse as the distribution headquarters for Texas, Louisiana, and Mississippi. This Perkins-Smith railroad crew in 1903 includes, from left to right, Charles E. Moffitt (1871–1944), Gus Heffner (1879–1954), and Lynn T. Perkins (1874–1968).

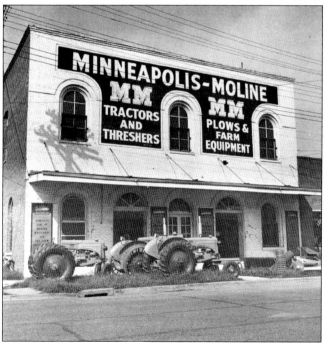

This two-story brick building, located at 103 North Avenue F, housed the Lawrence Brothers Warehouse, operated by P.L. and L.H. Lawrence, and Nutriline Feed & Oil Company between about 1904 and 1918. In the early 1920s, Sebastian Haydel operated a mercantile store. Minneapolis-Moline opened about 1938. Later, August Leonards' family owned an implement business here. It closed about 1960. NAPA Auto Parts later operated in this building. The current owner, Stan Gall, leases the building.

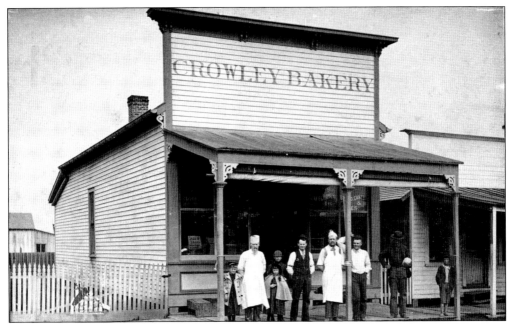

A Crowley Bakery was operating as early as 1890. An advertisement noted the sale of groceries and requested eggs and country produce from farmers. Lester Greene purchased the bakery in 1894. William Bernard Kelley (1859–1906) is seen here, second from left. He is flanked by his daughter Carrie (born 1889) on the left and his stepdaughter Ethel Johnson (born 1891) on the right. His family came to Crowley about 1900 and operated a bakery.

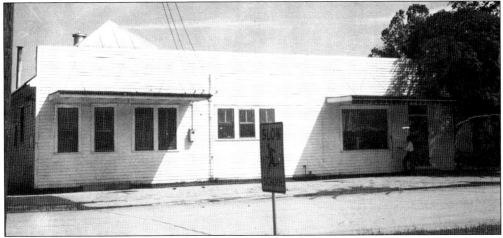

James Robbins (1864–1935) opened South Crowley Bakery, located at 1001 South Parkerson Avenue, in 1921. The Robbins family consisted of Jimmy (1899–1960), Teddy (1904–1995), Stone (1908–1995), Woodrow (1912–1986), Sigmund (?–2003), Pershing (1916–1960), Elizabeth (1901–1994), Eola Colton (1905–2004), Helen Sargent (1911–1984), and Emma Short. The family continued the business until 1966, when it closed. Open 24 hours, the bakery advertised that its "ovens are never on vacation."

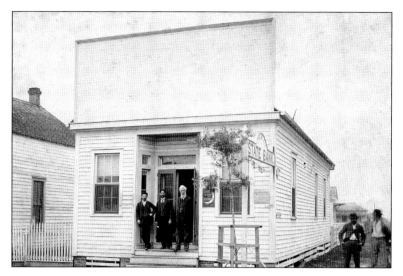

Organized in 1892, Crowley State Bank was the first bank in town. Standing in the doorway of the original frame building, located on the southwest corner of Parkerson Avenue and Second Street, are John Pintard (left), Guy Norton (center), and William E. Ellis.

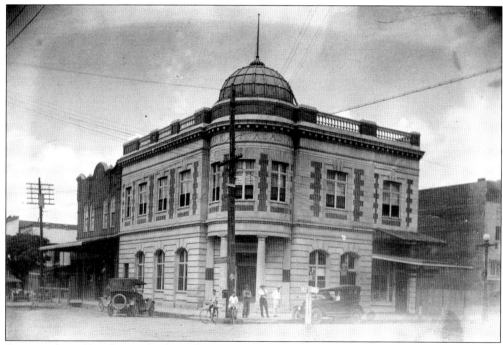

Organized in 1898, the Bank of Acadia moved into this two-story, brick-and-limestone building in 1902. With its failure in 1931, the institution was acquired by the Bank of Commerce. In 1936, the building was sold to Crowley Building & Loan Association, which had offices there until 1975, when it moved to a new building. The dome was later removed because of its deterioration.

Crowley State Bank erected a brick building in 1894 at 204 North Parkerson Avenue. Reorganized in 1912 as the Crowley Bank & Trust Company, the bank failed in January 1926. By April, it reopened as the Bank of Commerce, with Abrom Kaplan serving as president until 1931. The building was razed in 1963; however, the original safe was moved into the Bank of Commerce's new home on Avenue G. Shown below inside the bank's brick building are, from left to right, John Pintard, Preston Lovell (president from 1892 until his death in 1915), Guy Norton, and William E. Ellis (president from 1915 until his retirement in 1920).

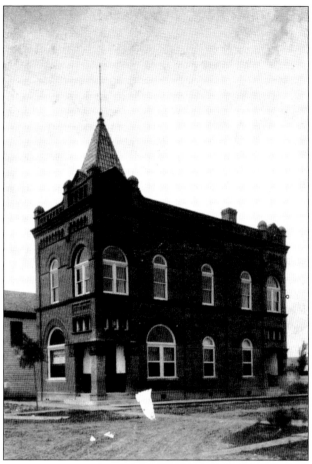

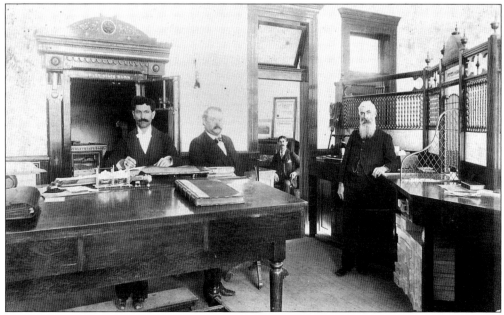

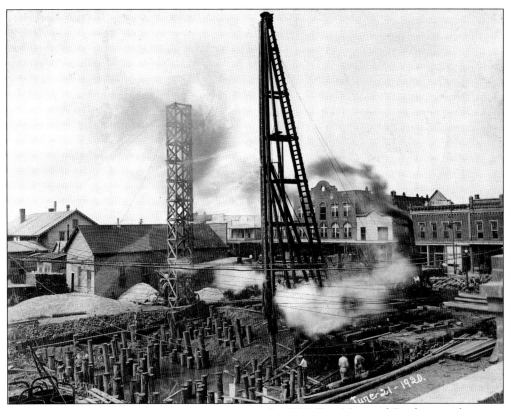

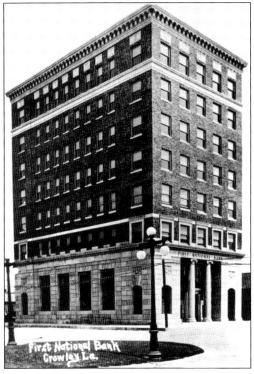

In 1900, First National Bank opened, with Thomas J. Toler, president, and P.L. Lawrence, cashier. Originally, it was located across the street from its present site, which was purchased in 1906. Elected president in 1918, Lawrence announced plans for a seven-story bank building. Construction began in February 1920. The above photograph shows some of the 350 cypress pilings driven into the ground to ensure a firm foundation. During construction, an accident occurred when a construction hoist snapped, dropping bank officials T.B. Freeland, L.M. Davies, George Thomson, Lawrence, and two construction officials 20 feet into the basement. Tragically, Thomson died of head injuries. During the grand opening on August 1, 1921, many of the 3,000 attendees went up on the roof to view the city. At the time of its construction, it was the tallest building between Houston and New Orleans.

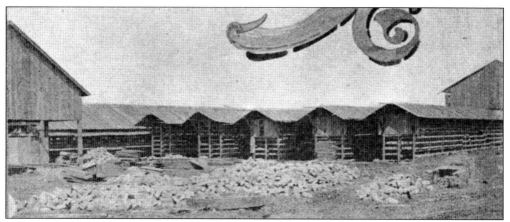

The Acadia Brick Yard in South Crowley, at the Rice Festival Building area, operated from February 1898 until at least 1909. It had a capacity of 20,000 bricks per day. Pictured here are four drying sheds, each capable of holding 50,000 green bricks. The burning shed had a kiln in which the bricks were made.

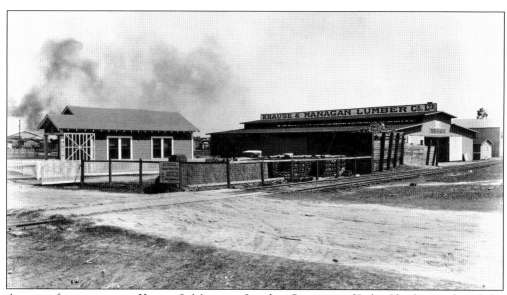

As part of its expansion, Krause & Managan Lumber Company of Lake Charles purchased the Crowley Lumber Company in 1927. Operating under its new name, the Crowley acquisition, located at 120 North Avenue F, was managed by E.E. Hoag. In the 1920s, A.B. Core Sr. took over management. The business closed in 1970.

Toler Lumber Yard, pictured in 1898, was owned by Thomas J. Toler (1859–1937) and Gus Fontenot (1859–1926), who had purchased the old Collins & Duson Lumber Yard. Sold to P.G. LeBourgeois and Dan H. Fruge in 1926, the operation continued as Acadia Lumber Yard. In 1936, Wade Burt and Fruge purchased the business. In 1949, Fruge (1903–1992), who had started working for Toler in 1924, became sole owner.

Horace Eugene Lewis (right) established Stewart & Lewis Lumberyard with W.C. Stewart in 1898. Lewis (1874–1950) bought Stewart's interest and operated solo from 1903 until 1950. Due to ill health, he then sold it to William J. Cleveland (1902–1974). Lewis's home (see page 85) was one of the most beautiful in South Crowley.

Acadia Garage, chartered in 1916 by J.T. Hinchliffe (1880–1935), was purchased by Emile "Chief" Savoie (1883–1979) in 1919. Changing the name to Cash Auto Supply, he transformed the building in 1920, as shown here. Upstairs was one of the largest inventories of tires in the state. Located at the corner of Avenue G and Fourth Street, the building was purchased in 1921 by Gary Bergeron (1897–1962) and closed in 1966.

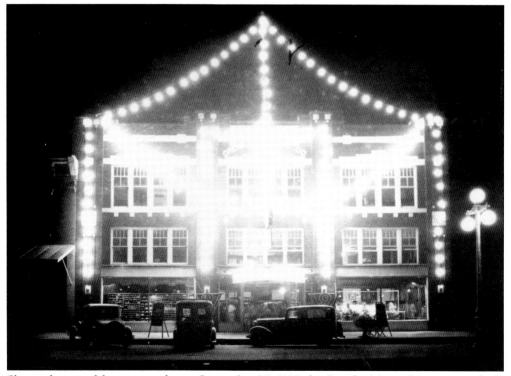

Shown decorated for opening day on September 26, 1921, the Crowley Motor Company was built by contractor H.J. Andrus. This first Ford dealership operated until 1963. Originally, cars were shipped unassembled and dealers put them together. James "Scotty" Boggs opened the business; J.A. Finley was a longtime manager. Salmon Brick Company provided 200,000 bricks for the building, and nine bricklayers completed the job. Local plumber and electrician J.W. Miles worked on the project.

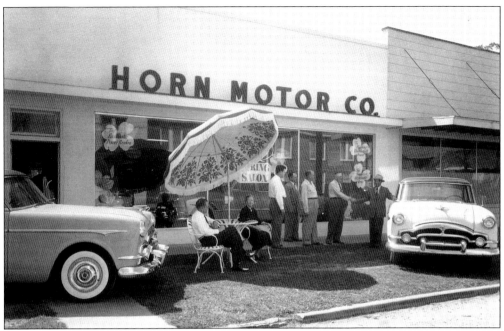

Horn Motor Company, located at 219 North Avenue F, was owned and operated by Albert F. Horn Sr. (1883–1961). The company existed from 1934 to 1959. Seen here is the formal opening of its newly enlarged quarters in 1948. The new addition provided a large, modern showroom for the Packard automobile, for which Horn had been a dealer since 1938. Currently, Suire's Front End Alignment operates in this building.

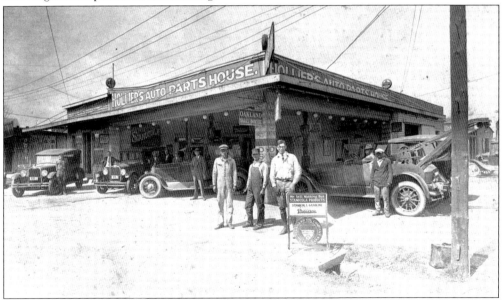

Hollier's Auto Parts House, shown here about 1925, was located at the corner of North Avenue F and Second Street; it closed in 1941. Owner Larry Hollier (1881–1942) came to Crowley in 1902. His spouse was Lillian Keller. Hollier sold Oakland automobiles, manufactured from 1909 until 1931 as a division of General Motors. Hollier is standing to the left of the second automobile from the left.

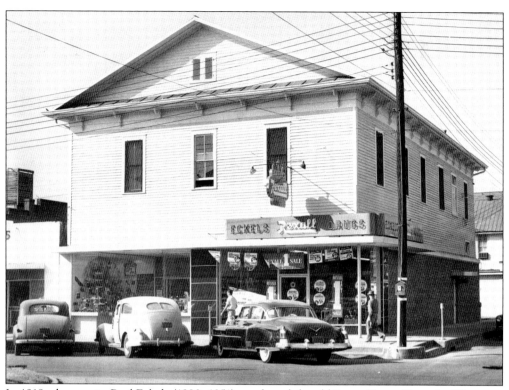

In 1918, pharmacist Paul Eckels (1880–1951) purchased the old Favre Opera House building, out of which he operated a drugstore, seen above, until 1957. At that time, it was demolished and replaced with a one-story brick building. The interior of Eckels Pharmacy is pictured below around 1921. Shown here are, from left to right, unidentified, Ivy Breaux, Paul Eckels, unidentified, George Eckels, Possum Andrus, and unidentified.

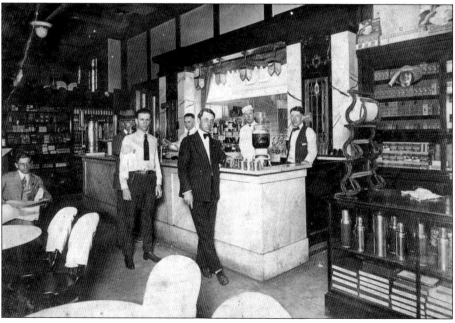

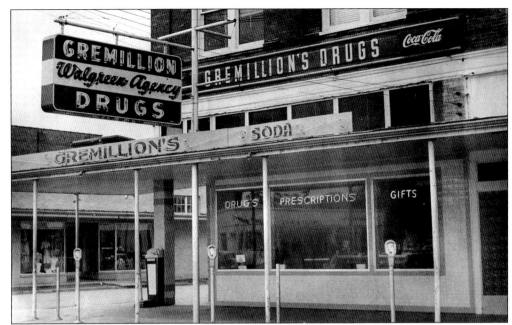

At 401 North Parkerson Avenue, Preston Knobdell, Joseph Sabatier, and Samuel Eldrich operated stores. In 1913, Eldrich had the original frame building bricked. The Knights of Columbus occupied it from 1920 until 1941. At that time, Wiley Gremillion moved his pharmacy, opened in 1934, into this building. In 1965, Paul and Laura "Tee" Broussard bought the pharmacy, which continues to operate under proprietor "Tee" Rosenbaum.

Geesey-Ferguson Funeral Home, cofounded by Lloyd P. Geesey (1893–1951) and his brother-in-law A.M. "Bunny" Ferguson (1902–1971), was opened in 1934. They came to Crowley from Dallas, where they had a monument and vault business. They purchased Toler's funeral home from Steven Toler's widow, Esther. A red-brick building was erected five years after this photograph was taken in 1948; however, a part of the original building was bricked over.

Crowley's first hospital, known as Crowley Sanitarium, was located on First Street, about four blocks east of Parkerson Avenue. It was formed in 1907 under Drs. E.M. Ellis, Zachary Francez, and J.E. Ludeau. In the photograph above of South Parkerson Avenue, taken in July 1913, the Crowley Sanitarium can be seen (center background) on Oak Street. This two-story building was the Commercial Hotel until it was sold in July 1912 for use as the sanitarium. It served from November 1, 1912, until it was destroyed by fire on December 19, 1913. The Crowley Sanitarium, seen below, was organized by Drs. Elijah M. Ellis (1866–1928), J.W. Faulk Sr. (1886–1966), A.B. Cross (1882–1949), M.L. Hoffpauer (1871–1930), and Ralph B. Raney (1869–1923). It was constructed in 1915 on Avenue K. The American Legion took ownership in 1929. This building was demolished in 1968.

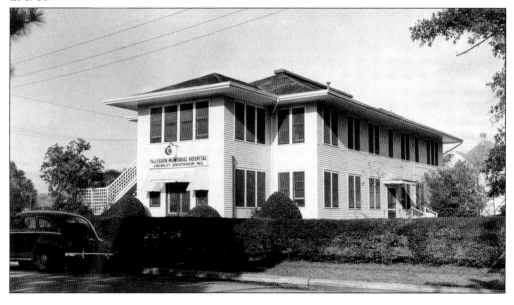

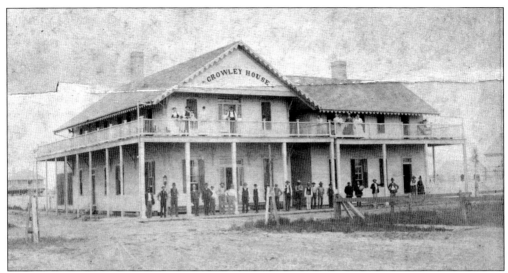

Constructed by W.W. Duson in 1887, the Crowley House, the town's first hotel, was located at the corner of First Street and North Parkerson Avenue near the railroad depot. It had accommodations for 100 guests. The hotel housed many of Crowley's first pioneers until their homes could be built. The first managers were Duson's sister Ellen and her husband, Colbert Foreman. Closed in 1970, the structure was demolished in 1972.

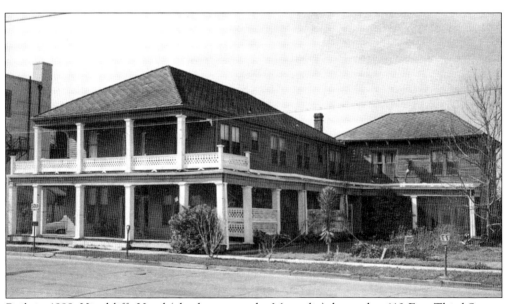

Built in 1888, Hinchliffe Hotel (also known as the Magnolia), located at 113 East Third Street, was owned by Col. Thomas Hinchliffe (1831–1909) and his widow, Rachel, until 1926. Purchased that year by J.B. McAfee, it was reopened as the Inn Hotel. It was later owned by Gary Bergeron and operated as a rooming house. It was torn down in 1967, and the new post office was built on the site in 1968.

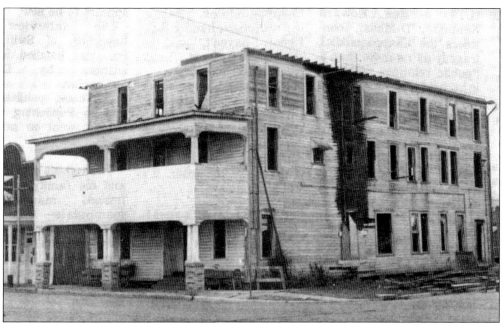

The Elma House, located on the east corner of Avenue G and First Street, was built on the site of the O'Quin Hotel, which burned down in 1903. It was rebuilt as the Jackson House, and George Sawyer (1866–1936) purchased it about 1912. Its name had been changed to Elma House by then. His wife, Elizabeth (1869–1955), and daughters Lela (1889–1973) and Lottie (1891–1984) continued to manage it as a hotel/rooming house until 1955. Lela (below, left) and Lottie (below, right) lived there until it was badly damaged by fire. The structure was demolished in 1979.

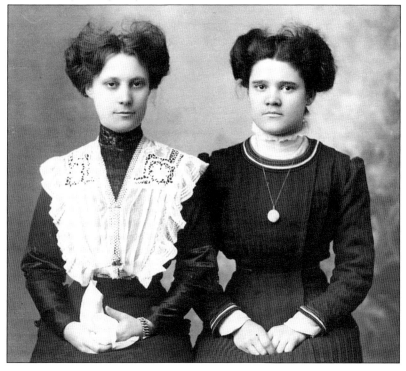

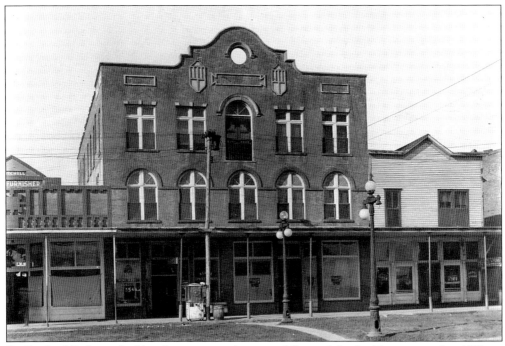

Dr. Raphael R. Lyons had his drugstore on the ground floor of this building, erected in 1901 on Parkerson Avenue. The top two floors were used as Hotel Pizzini (1907–1918) and Lyons Hotel (c. 1919–1927). Clem Anderson, whose wife, Lois, was the daughter of Doctor Lyons, established it as the Anderson Hotel (1935–1950). The photograph shows the building in 1922.

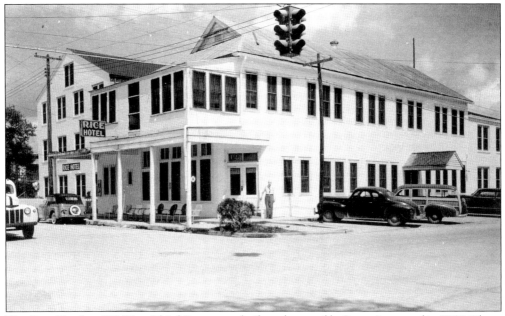

The Rice Hotel, at 125 West Third Street, was built and opened by James Lormand in 1909. There was a liquor business downstairs and 10 rooms upstairs. Lormand later bricked over the original building and added on to the east side of it. Ophelia Stutes (Mrs. W.X.) Moseley (1891–1973) was manager from 1927 until 1948. It ceased to operate as a hotel in 1999.

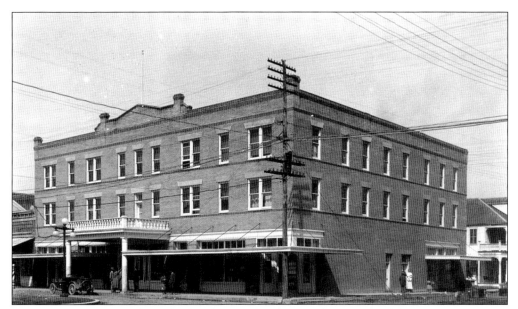

The Egan Hotel was the brainchild of the Egan brothers, William Michael (1868–1928) and John Francis (1866–1942). Located on Parkerson Avenue, it opened on January 1, 1914, with George Dorr (1872–1950) as manager. This modern hotel boasted hot and cold running water and private baths. Upon Dorr's retirement in 1917, Charles Albert (1885–1973) and Anne Egan (1879–1961) Peck assumed the management until its closure in December 1966.

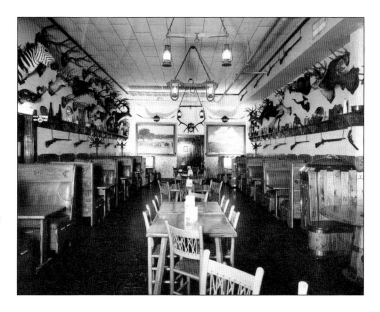

With an "atmosphere reminiscent of the Old West," Sud's Pioneer Bar held its grand opening in 1946. Owner Herbert Sudwischer (1904–1965), who came to Crowley from Lake Charles around 1931, operated the bar inside the Egan Hotel until the end of 1955. Constructed of knotty pine, all of the furniture, including some booths and a bar, were made by Sudwischer in his woodworking shop. (Courtesy of Jon Sudwischer.)

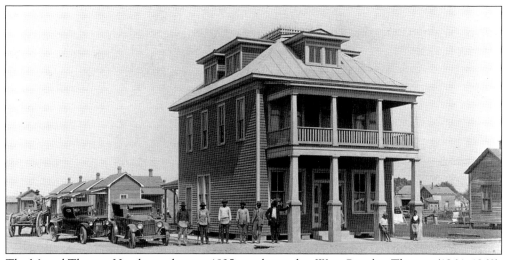

The Marcel Thomas Hotel, seen here in 1925, was located in West Crowley. Thomas (1864–1963), a prominent Crowley businessman and realtor in the African American community, also operated a patent medicine and herb business. His son Augustus (1893–1963) managed the hotel, which was put up for sale in 1935.

Taken in 1897, this photograph shows three businesses on the west side of Parkerson Avenue. They are, from left to right, Jacob White's Boarding House, Delgardo's Ice Cream Parlor, and an unidentified saloon/billiards hall with lodging on the second floor. White offered board and lodging by the week or month. The ice cream parlor featured pink punch (the popular 5¢ drink), milk shakes, and cool fruit sherbet.

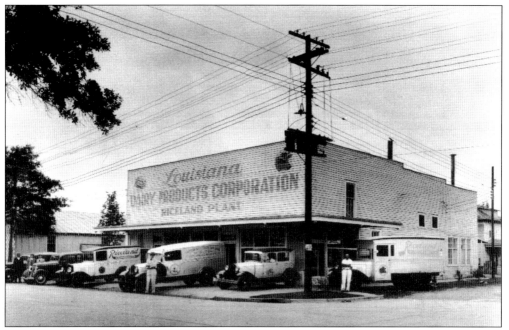

Riceland Ice Cream and Creamery was organized in 1923 by Albert F. Horn Sr. (1883–1961), who bought the Farrell Ice Cream factory located at 227 North Avenue F. It produced ice cream and Riceland butter, which was sold throughout southwest Louisiana. Later purchased by Louisiana Dairy Products Corporation with H.H. Brown (1905–1990) as manager, the Crowley plant was closed by 1940.

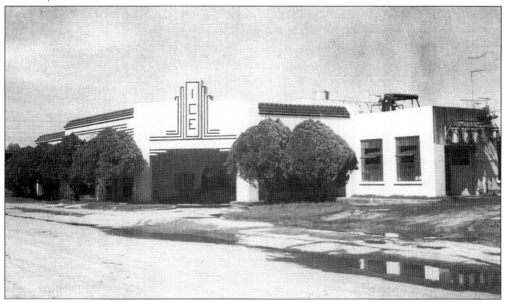

The Crowley Ice Factory, later called the Crystal Ice Company, opened in 1896. Built by J.G. McComiskey, it had a daily capacity of 12 tons. Albert F. Horn Sr., a one-time delivery boy, purchased the company in 1909, and a modern plant was constructed. This photograph depicts a later icehouse, the Home Ice Company, which operated from 1936 to 1970. Its first managers were James Barnett and Malcolm McCorkle.

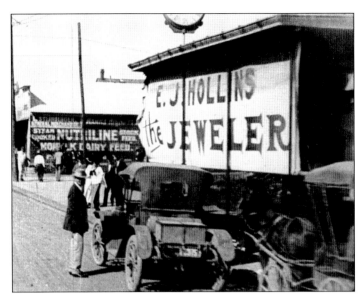

Edwin John Hollins (1871–1945) came to Crowley in 1904 and purchased Hollins Jewelry Store, which his brothers Arthur and William had established in 1896 at 324 North Parkerson Avenue. Edwin's spouse, Ava Rakestraw (1889–1972), was the daughter of Crowley pioneers Frank and Edna Lyons Rakestraw. On this site, two other jewelry stores operated: Faulk's, owned by Lottie Jones Faulk (1909–1986), and Edith's, owned by Edith Dailey.

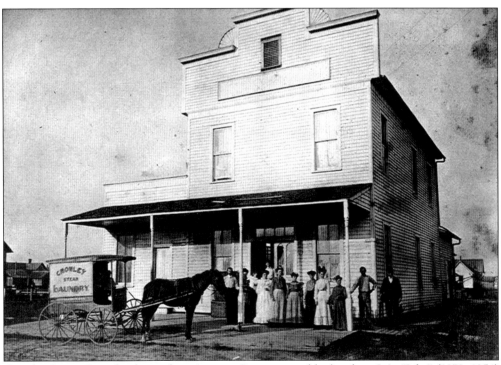

Crowley Steam Laundry, located on Avenue G, was owned by brothers J.A. "Jake" (1872–1954) and Henry (1879–1956) Hoffman, who later owned the Model Laundry on East Seventh Street. Patrons in town were serviced by free delivery wagons. The brothers later owned a grocery store. Although unidentified, those pictured here may be the brothers and their spouses, Daisy (1885–1968) and Susie (1888–1973), with their employees.

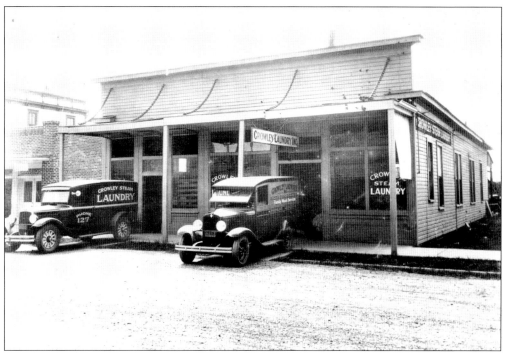

Crowley Laundry, owned and operated by Herbert and Vernie Sudwischer, opened in 1930. Their son Jon joined the firm in 1959. Located in the 100 block of East Second Street, the establishment burned down in 1932. It was then replaced by a brick building. Besides dry cleaning, the new facility provided a dry and cold storage vault for customers' furs and woolen clothes.

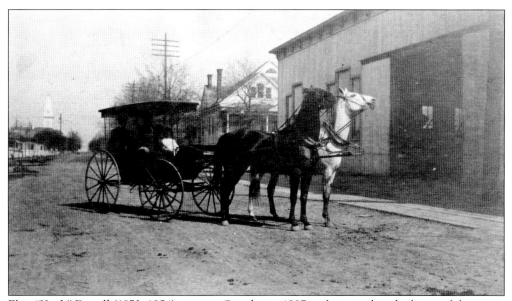

Elzie "Yank" Duvall (1870–1954) came to Crowley in 1897 and engaged in the livestock business, which included a sale and feed stable. In October 1905, he traveled to his native Missouri to purchase draft horses Rock and Riley for the fire department. Prior to that purchase, stables in Crowley had provided the fire horses.

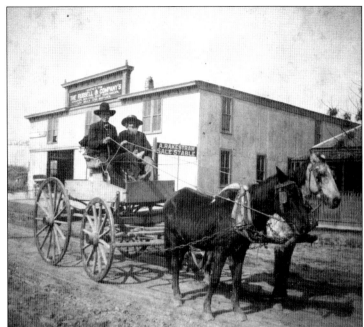

In 1902, Allen Rakestraw (1853–1931) had a sale stable. Located at the corner of Second Street and Avenue F, it also handled machinery such as engines, rollers, rice threshers, sawmills, and repairs. Later, he operated a stable on Fifth Street and Avenue F that leased and sold work and delivery horses as well as mules.

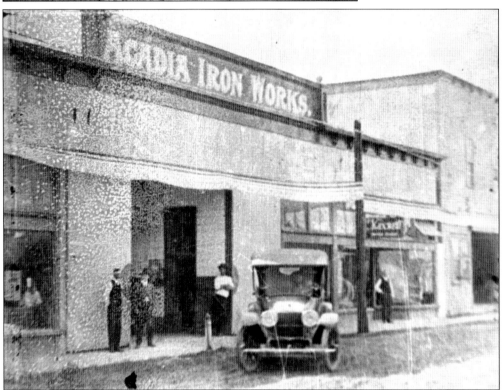

Established in 1892 by Col. Thomas Hinchliffe, Acadia Iron Works occupied a large building fronting Avenue G and Fourth Street. It specialized in selling and repairing machinery for irrigating pumping plants, rice and sawmills, and cotton gins. It appears to have remained in business into the 1980s, although the name changed to Acadia Machine Works in 1928.

Hanagriff's Meat Market was located on West Second Street. Opened in 1914, it was owned by Paul C. Hanagriff Sr. (1885–1944), whose slaughterhouse provided fresh meat. After his death, the market remained in the family, with his brother Beverly as the butcher. The business closed about 1960, when the building burned down.

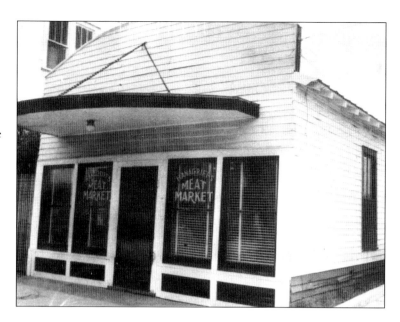

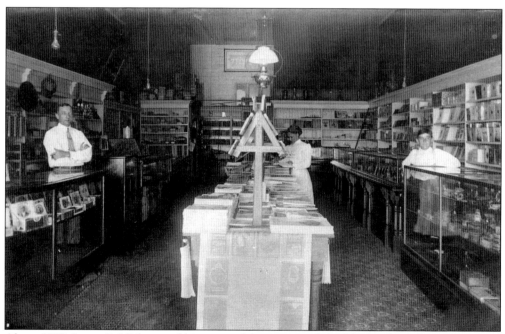

About 1902, James B. Niebert and his spouse, Murta, opened the Metropolitan Stationary Store inside the post office, then on Parkerson Avenue. It stocked newspapers, magazines, and books as well as tobacco products and novelty items, such as jewel cases. Murta is pictured in the center, with Ed Hill on the left and Ernest Capel (1895–1976) on the right. James, who died in 1933, was associated with the *Signal* newspaper.

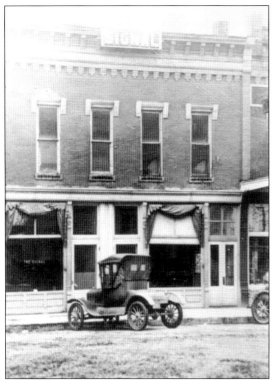

Thomas J. Toler owned the entire 100 block on the west side of Parkerson Avenue. The building at left, next to the corner building (which housed the original First National Bank, Kennedy's Store, and Nichols Department Store), was home to the *Signal* newspaper publishing business from 1901 to 1926. In 1926, the *Signal* moved its operation to the Duson building on the 300 block of the east side of Parkerson Avenue. On moving day, seen below, Calise Trahan stands on the Duplex press. Standing on the sidewalk are Bill Dugan (left), Mr. Rich (center), and Luther Ellis.

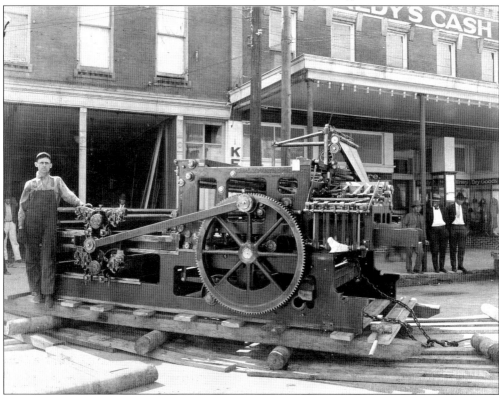

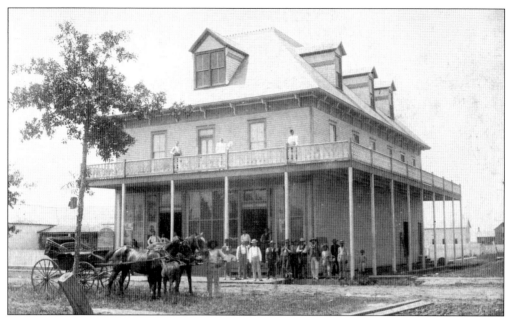

Favre Opera House, located on the corner of Parkerson Avenue and West Third Street, was built in 1892. William Favre (1854–1904) and his wife, Elizabeth Coslett Favre (1838–1918), came to Crowley in 1887. The opera hall occupied the second floor, while the ground floor held Favre's saloon. Crowley's first photographer, George Bellar, who took this image, had his studio on the third floor. In 1899, the top two floors were converted into a hotel.

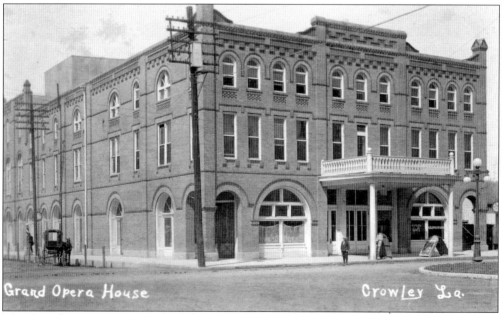

The Grand Opera House was built by Dave Lyons (1867–1940) in 1901 on the location of his livery business. Besides live stage and vaudeville shows, the facility also hosted graduations and political speakers. From 1913 to 1940, silent and "talkie" movies were shown. Dixie Hardware operated in the building from 1942 to 2008. Under the guidance of the L.J. Gielen family, the facility was restored and once again presents live entertainment.

Photographers B.A. Barnett (1876–1956) and his father, Eli (1841–1927), came to Crowley in 1897. On West Second Street, they opened a photography studio. Later, B.A. and his son Nevin (1901–1960) owned Barnett Paint & Glass Company. In 1963, Herbert Foreman, who had worked for Barnett, purchased the glass business. Herbert "Bubba" Jr. joined the firm, which continues in operation.

In 1901, the Miles family started a plumbing and electrical business on Parkerson Avenue. Brothers John Wesley (1877–1948) and Gilbert (1872–1910) stayed involved, and they were also active in the fire department. Their brother W.T. "Tom" Miles (1873–1960) organized the business in 1929 with his son Ivy as W.T. Miles & Son. Other family members were employed in the business. It closed in the early 1980s.

Built around 1887, Jacob White's hotel moved to West Third Street from Parkerson Avenue when the Acadia Theatre was built in 1919. Harry Lambousy and Harry "Papa Dick" Zanos operated it as the Acadia Café from 1939 to 1944. Barney Hart owned it the next two years. Well-known Crowley chef Albert Lopez (1909–1993) assumed ownership/management in 1946 until his retirement in 1990, when the business closed. Specialties included seafood, steaks, and Mexican dishes.

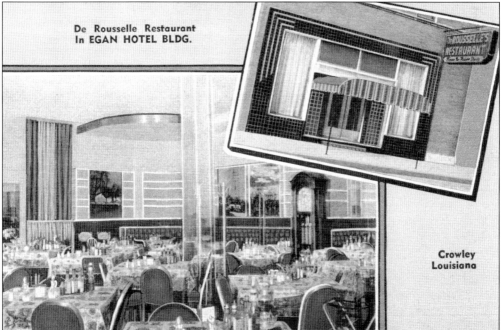

Located in the Egan Hotel Building, with an entrance on Third Street just off Parkerson Avenue, DeRousselle's Restaurant was open from 1946 until 1959. Its interior featured photomurals of Louisiana scenes. Its owner and operator was Clarence DeRousselle (1912–1969).

Born in Greece, brothers George (1891–1945) and Mitchell (1894–1949) Mamoulides arrived in Crowley in 1918 and 1920, respectively, and became involved in the restaurant business. Mitchell originally managed Acadia Confectionery and then opened Welcome Bar and Café. George opened People's Restaurant (pictured) on Parkerson Avenue in 1918. Herbert Naomi Sr. (1903–1991) purchased and managed the business from 1940 until 1946.

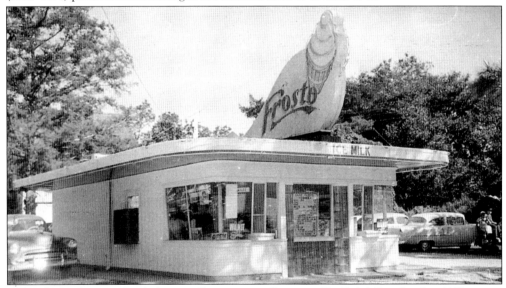

Frosto, located at 228 North Avenue-G, was originally opened by Ralph Roseland in 1950 as part of the Zesto national chain. The business served hotdogs, ice cream, and sodas. In 1955, Helen Larive Lafosse assumed control of the business, which she renamed Frosto. The menu expanded to include homemade hamburgers. In the 1960s, Lafosse's daughter Lola Trahan became a partner in Frosto. Her son Brannon continues the business. (Courtesy of Lola Trahan.)

Erected by Henry Loewer, the building shown here was bought in 1902 by brothers-in-law George B. Thomson and Claude C. Lyons, who operated Thomson-Lyons Implement Company. In 1913, August Reiber purchased Lyons's share, and the name became Thomson-Reiber. In 1924, the Alphee LeBlanc family assumed ownership and continued the hardware business until 1950, when Jake Brandt moved his furniture business, begun in 1937, into the building. Dave Antis started his jewelry store in Brandt's in 1954.

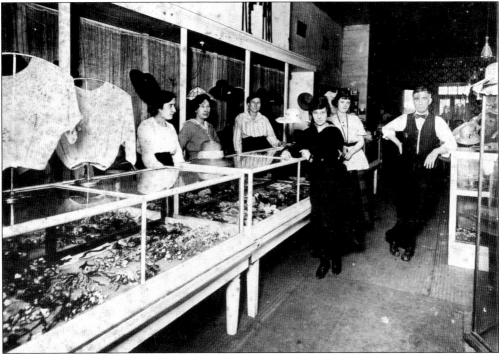

Shown here is the interior of Egan's Department Store, located beside the Egan Hotel on Parkerson Avenue. From left to right are Clotile Meaux, Austine Guidry, Ernie Hayes, Stephanie Broussard, Blanche Barnsdale, and proprietor Dan Egan.

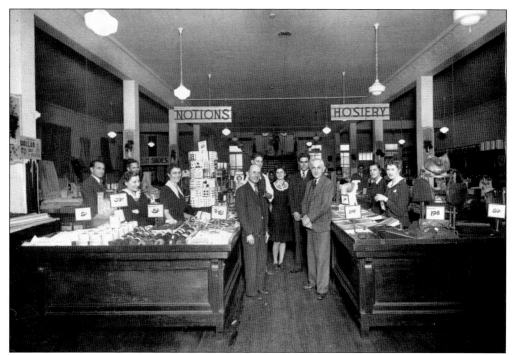

Heymann's Department Store opened about 1920 in the Frankel building in the middle of the 300 block of Parkerson Avenue. Maurice Heymann (1886–1967) added a grocery department in 1926. In 1940, he constructed a new building on the corner of Fourth Street and Parkerson Avenue. Heymann's closed in 1958. Among those shown her are Callie Broussard, in the center, with Huey "Pete" Watson to the right of her and Curley Lasserre, partially obstructed, to the left.

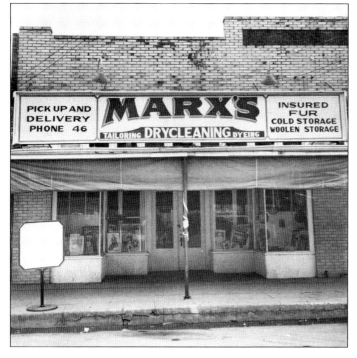

Paul Centennial Marx (July 4, 1876–1949) came to Crowley from New Orleans in 1895 and opened the first drycleaning and pressing shop as well as tailoring business in Crowley. Described as a gentleman of unquestioned integrity, he retired in 1947. His son Elmo (1912–1972) continued the business until his retirement in 1970. Located at 424 North Parkerson Avenue, the building was erected in 1919.

In 1897, Elwin H. Ellis (1870–1905) opened a hardware store on Parkerson Avenue, seen at right. John McAyeal (1854–1915) bought the store about 1900 and, with the purchase of the drygoods business of the Stagg Brothers in 1905, the two stores were consolidated. The store was relocated in the Egan building in 1915, and Dan Egan (1871–1957) purchased the business. Shown below in 1910 in the doorway of McAyeal's Drygoods and Millinery Department are, from left to right, Austin Guidry, Maude Germer (the future Mrs. Dan Egan), and Dan Egan.

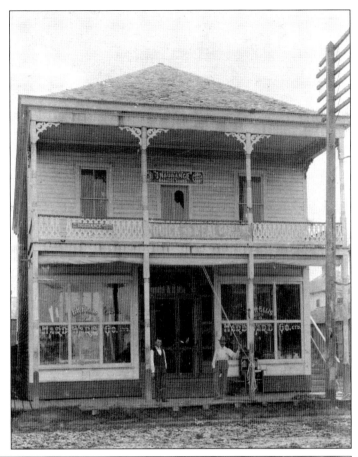

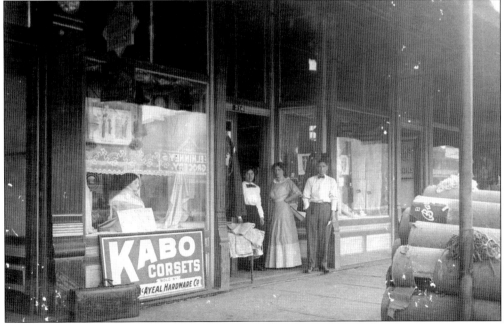

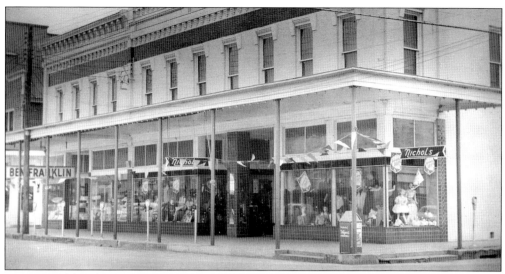

Constructed by Thomas J. Toler in 1900, the buildings on the 100 block of the west side of North Parkerson Avenue have housed Toler Hardware, First National Bank (1902–1921), and Kennedy's Cash Store (1912–1949), owned by Wilbur A. and G.A. Kennedy. Kennedy's Store handled clothes, groceries, and hardware. When Steve Johnston joined Kennedy, the name changed to Kennedy-Johnston and operated as such from 1950 to 1956. Shown here is Nichols Department Store, which operated from 1956 to 1990.

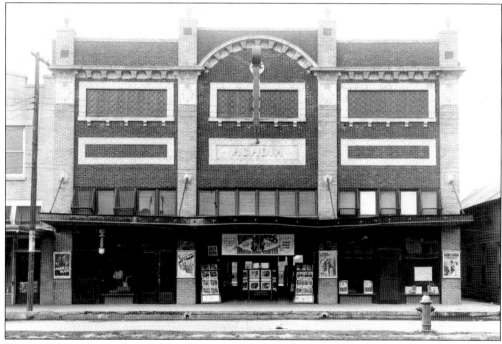

Crowley's first movie theater, John Pintard's Electric Palace, featured nickelodeon shows. It was closed by the time the Acadia Theatre opened in 1919. Located at 215 North Parkerson Avenue, the Acadia was built by the Southern Amusement Company. It featured a Typhoon Cooling System. Ruby Halleman was the organist for silent movies. Closed in 1955, the building now houses Cajun Blaze Graphics and Core Dance Center.

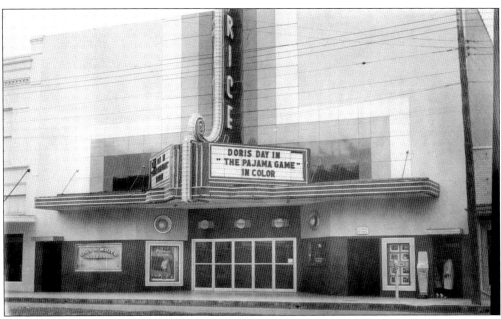

The Rice Theater (1941–1983), located at 323 North Parkerson Avenue, was also built by the Southern Amusement Company. It boasted a seating capacity of 700 on the ground floor and 300 in the balcony. Its official opening was delayed several months because of flood damage in August 1940. Purchased by the City of Crowley in 1986, the venue was restored and now hosts various events and theatrical performances.

The Star Theatre, on West Hutchinson Avenue, was owned by Clyde LeBlanc (1915–1981). This venue, which existed from 1947 to 1967, served African Americans. Interestingly, the balcony was reserved for whites. One of the tallest buildings in West Crowley, it was later torn down. Pictured here are Clyde LeBlanc and his grandchildren, Deborah (left), Connie (in his arms), and Barry. (Courtesy of Dolores LeBlanc Nutt.)

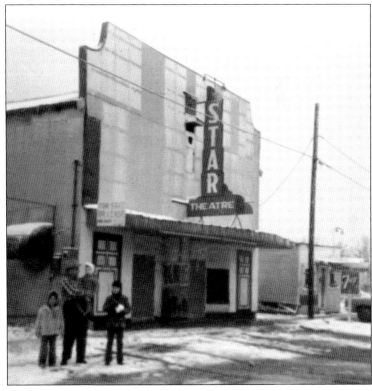

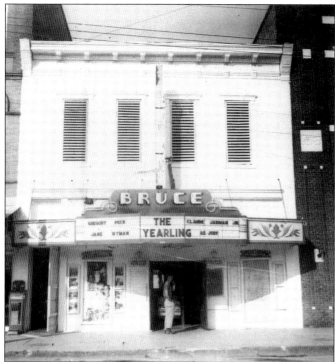

The Bruce Theatre, located at 417 North Parkerson Avenue, was owned by A.J. Broussard (1897–1971). The building was erected in 1901 by Robert Mull (1861–1924). Broussard operated Broussard Gas and Electric Shop from 1938 until 1940. He then converted the building into a theater with a seating capacity of 313. The Bruce Theatre operated from 1940 to 1956.

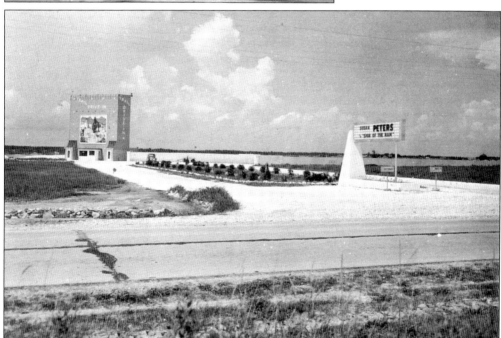

A.J. Broussard owned two other theaters. The Trail Drive-In (pictured), on Highway 90, operated from 1949 to 1968. With accommodations for 300 cars, it offered a speaker for each car. Refreshments from the concession stand were served directly to the car. The Chief Theater, located on the 1600 block of North Parkerson Avenue, opened in 1954. The steel building could seat 1,000 people. Destroyed by Hurricane Audrey in June 1957, it never reopened.

Six

RESIDENCES

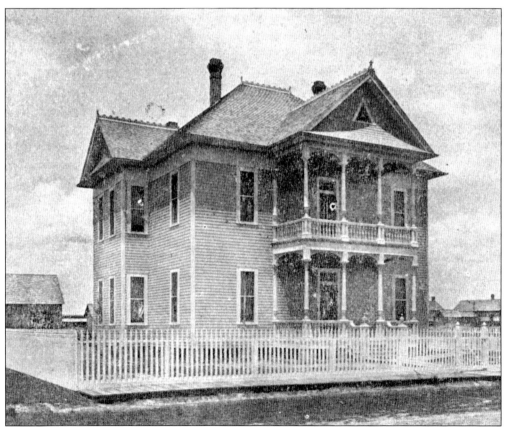

Contractor James A. Petty (1856–c. 1920) spent a few years in the late 1890s and early 1900s in Crowley designing and constructing homes, rice mills, and the Duson Building. He built his residence at the corner of South Avenue G and Sixteenth Street (now Oak Street). By 1910, Petty, his wife Harriet, and their children had moved to New Orleans.

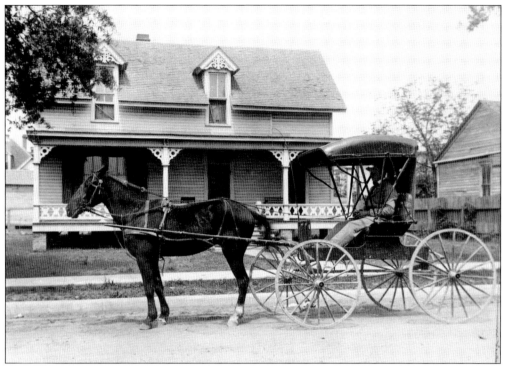

Jac Frankel (1859–1941) built his first residence on West Second Street in 1887. The one-and-a-half-story Queen Anne cottage was built next to his store, the first in Crowley. His home until 1902, it was later occupied by Fred Button (1872–1923), who had a paint and wallpaper store. The home appears in many photographs of early Crowley, as Barnett's Photography Studio was across the street. The image above shows Maurice Trahan in his buggy in 1919. Frankel's second home, on East Fifth Street and Avenue H, was constructed by Charles Hormell. The residence, shown below, had 14 large rooms. It was later demolished.

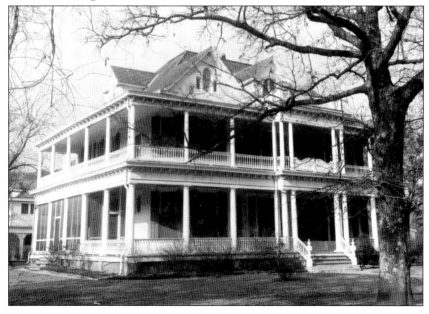

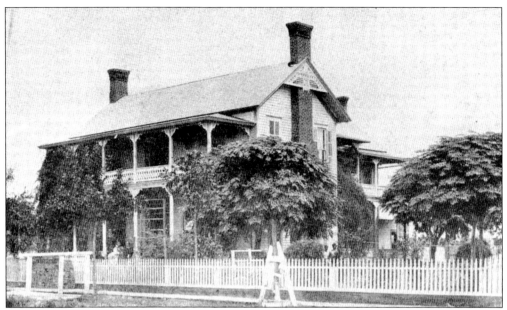

Thomas J. Toler (1858–1937) was employed by the Duson Brothers when he first came to Crowley. Originally, he built a cottage at 514 North Avenue H. His business interests included a lumberyard and the First National Bank. In 1892, he constructed a two-story home (above) with Eastlake galleries and eight fireplaces. Later, he remodeled the home (below), removing the second story and its porch. The one-and-a-half-story Queen Anne home also featured a large turret over a side porch, which was supported by Doric columns surrounding the house. Other residents have included William E. Lawson (1868–1936), a merchant, banker, and rice miller; and C.A. Peck (1896–1973) and his wife, Annie Egan (1878–1961), managers of the Egan Hotel (1918–1960s). Since 1975, the owners of the home have been Homer Ed and Carolyn Barousse.

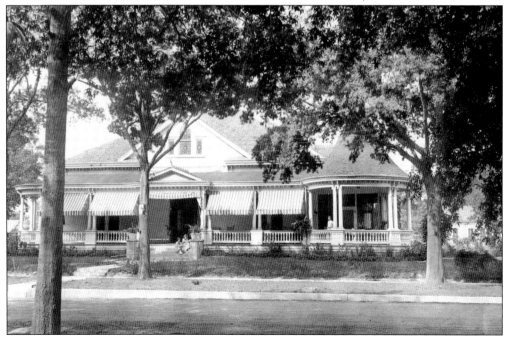

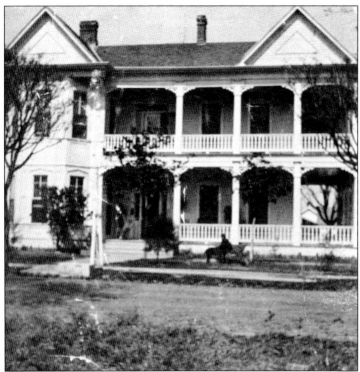

The home of Dr. Derrick Peterson January (1837–1904), located at 223 East Hutchinson Avenue, was built in 1893. The Queen Anne–style home originally had porches; the Greek Revival columns were added later. Besides being Crowley's first physician, January served as Crowley's first mayor for 10 months in 1887. The home is currently owned by Sara Smith (Mrs. Leonard) Hensgens.

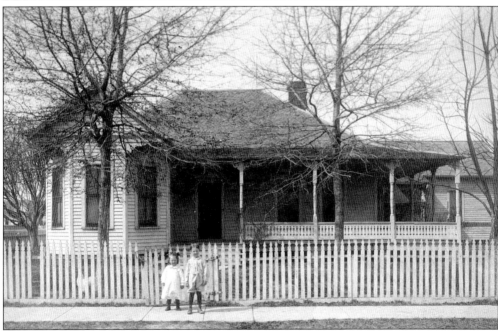

Built about 1895, this was home to John Hiram Lewis (1867–1942) and his spouse, Allie Johnson (1871–1949). A pioneer educator, he came to Crowley in 1895 and taught at Acadia College before building Crowley University near his home on East Eighth Street. He served as Acadia Parish Education superintendent from 1906 to 1913. Taken about 1912, this photograph shows two of their children, Marian "Mazie" and Charles.

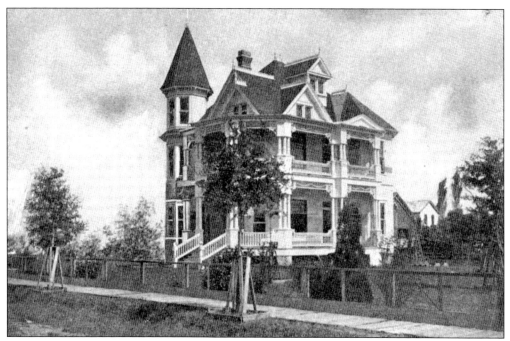

John Green (1848–1934) built a large, two-story Victorian home in 1895. The building featured a turret and galleries on both floors. Green brought his family to Crowley in 1891 and became involved in the rice industry as a farmer and manager of Crowley Rice Mill. The couple's daughter Daisy Green Louck (1885–1962) remained in the home until her death. The current residents are the Dr. Michael Holland family.

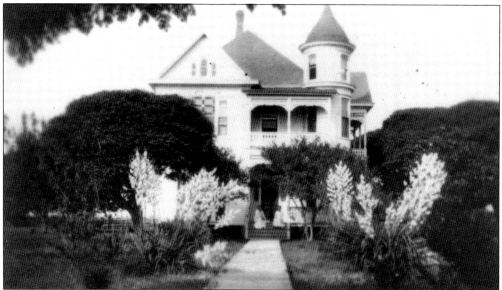

This two-and-a-half-story Queen Anne frame house with Eastlake galleries was built by contractor Charles Hormell for John Roller (1856–1936) in 1896. The original peaked turret was removed. Roller and his wife, Alice, came to Crowley with her brothers, C.J. and T.B. Freeland. Located at 216 North Eastern Avenue, the building was also home to Frank and Jessie Milliken, owners of a florist shop. The current resident is Barbara (Mrs. Fred) de la Houssaye.

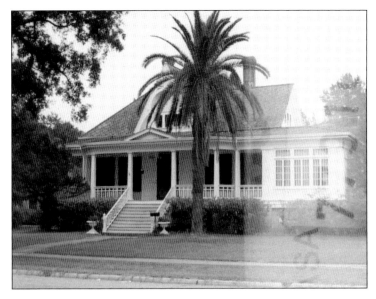

This one-and-a-half-story Queen Anne–style raised cottage with Eastlake galleries was the home of Philip J. Chappuis (1865–1942). Built in 1898, it is located at 526 North Avenue G. Moving to Crowley in 1889, Chappuis not only practiced law for 55 years, but he also served two terms as mayor (1894–1898 and 1902–1906). This home's current residents are Clay and Mitzi LeJeune and their children.

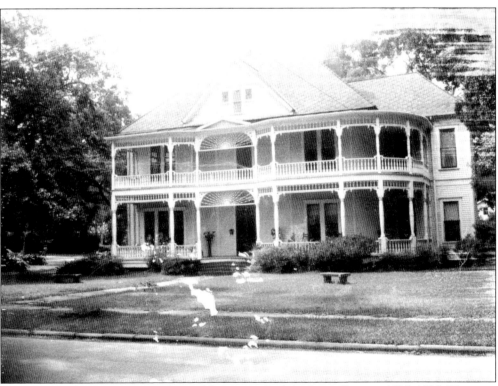

This 10-room home at 305 East Second Street was built by James Petty in 1898–1899. The two-and-a-half-story Queen Anne–style structure featured Eastlake galleries and balustrade porches. Raymond Thurston Clark (1855–1911), Acadia's first clerk of court (1887–1904), and his spouse, Laura (1856–1932), sister of W.W. Duson, had nine children. Daughter Hilda (1884–1976) retained ownership of the home until her death. A later resident, Jack Miller, made renovations. The current owner is Dr. Patrick Dale LeLeux Jr.

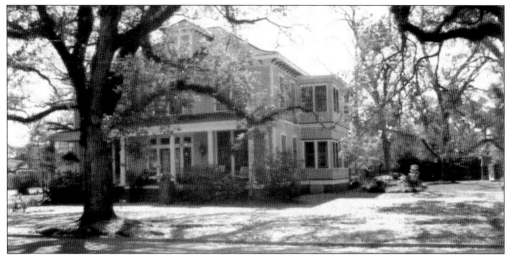

Built in 1901 for Bernice "Uncle Bun" Lambert, this two-story house featured balustrade porches. The original home had a turret on the east corner. The bay window and multipitched roof display a Victorian influence. A pioneer planter, Lambert (1862–1935) married May Knickerbocker (1878–1972). They later moved to Maxie. Later owners, Tommy and Mary Freeland, made renovations. The current residents of the home, at 322 East Third Street, are Dr. Mark and Diana Broussard and family.

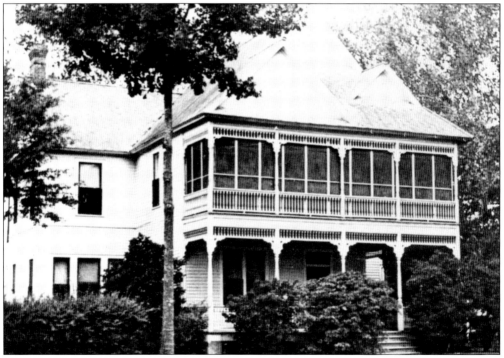

Located at 119 East Elm Street, the residence of Horace Eugene Lewis (1874–1950) was built in 1905. Constructed on cypress pilings, the two-story Queen Anne home features Eastlake galleries on both levels. Owner of the Lewis Lumber Yard in South Crowley, Horace was married to Lillian Archer (1876–1941). Their daughter Murle (1900–1984), longtime Crowley High School teacher, lived here until her death.

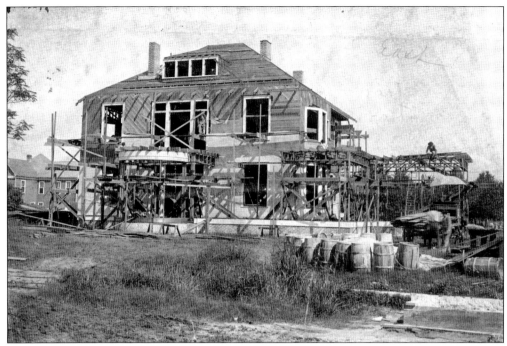

This two-and-a-half-story frame Colonial Revival residence with Doric columns, located at 219 East Second Street, was built in 1906 by Percy Lee Lawrence Sr. (1873–1939) for his new bride, Mamie Duson (1876–1969). She was the daughter of W.W. Duson. Associated with Duson's real estate business and the First National Bank, Lawrence came to Crowley from Mississippi in 1892. Suffering a fatal heart attack at home, his body lay in the home's library prior to his funeral service, which was held at the Presbyterian church because the Methodist church was undergoing repairs. Lawrence's son P.L. Jr. (1907–1999) and his spouse, Elizabeth (1913–2003), also resided in the home. Upon Elizabeth's death, William Hoffpauer (1932–2008) and his wife, Katherine, purchased and renovated the home. In 2001, the home returned to the Lawrence family when P.L. "Lee" Lawrence III and his spouse, Pattie, purchased it.

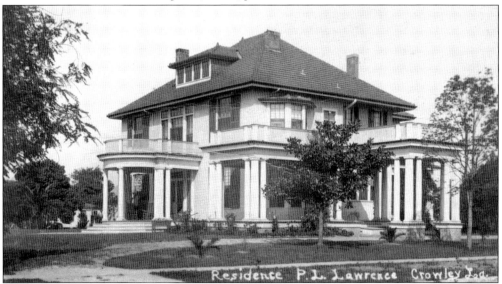

W.W. Duson built this home on First Street in 1902. Early on January 31, 1909, a piece of coal fell from an open fire in a second-floor room. Quickly burning through the floor and ceiling of the room below, fire spread throughout the house. Telephone connection delays resulted in firefighters arriving late. In less than an hour, only a few charred timbers remained. Fortunately, there were no injuries.

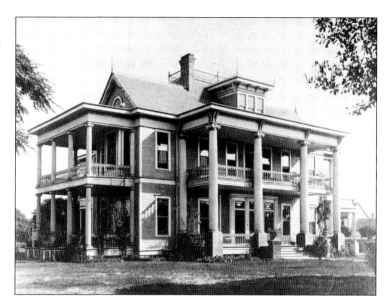

Abrom Kaplan (1872–1944), a pioneer businessman in the rice and banking industries, built a raised New Orleans–style cottage at Fourth Street and Avenue G in 1892. He moved the house to Avenue K in 1917. Set over an enclosed basement, the house was enlarged several times. While writing about the rice industry in *Blue Camelia* and *Victorine*, Frances Parkinson Keyes lived here. It was demolished in the 1990s.

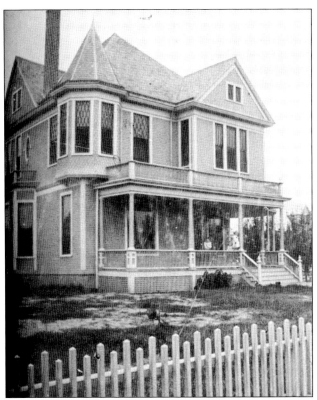

Built in 1901 by Elwin Herbert Ellis (1870–1905), the home on East Third Street, seen at left, featured a side turret and wide front gallery. Ellis came to Crowley in 1894 and established a hardware and lumber business. Crowley mayor Shelby Taylor lived briefly in the home before leaving Crowley in 1908, when he was elected Louisiana railroad commissioner. In 1917, W.W. Duson moved into the home. He died in a downstairs room in 1929. Rice broker James Trotter and his family renovated the home while living there, seen below. Since 1970, Dr. Cason delaHoussaye, a local obstetrician/gynecologist, and his spouse, Isabella, who served as Crowley's first female mayor, have lived in the home.

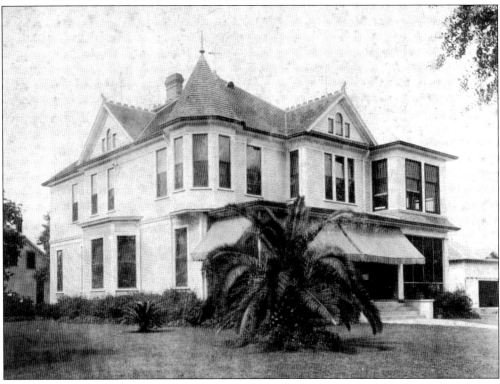

Businessman Dan Feitel (1887–1968) built his residence at 220 East Third Street in 1920. The two-and-a-half-story Tudor home featured a matching two-story garage. Feitel, a bachelor, shared the house with his niece Hazel Kollitz (1898–1970). The house remained in the family until her death. Interestingly, he exchanged houses with Dr. M.L. Hoffpauer for one year. The garage is now a bed-and-breakfast. Pictured are Feitel and his niece.

Emma Morris (1871–1902), the widow of Dr. James Franklin Morris (1856–1901), had this home built in 1902; however, she died before moving in. From 1909 until 1958, Thomas Barton (1867–1940) and Stella (1876–1958) Freeland lived here. Located at 304 East Third Street, this combination Greek Revival/Victorian residence was home to several members of the John N. John family.

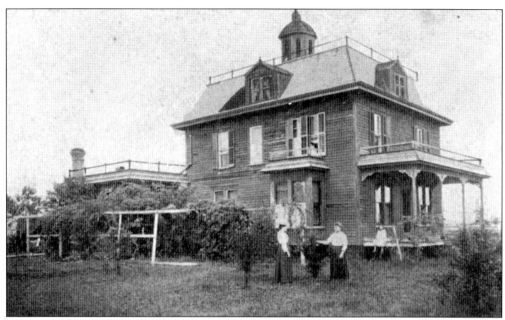

Thomas Jefferson Thayer (1832–1899) came to Crowley from Minnesota in 1888 with his family. He was active in the rice industry. When his wife, Mary, died in 1891, he returned to Minnesota and married Eliza Jane Wilder. Rose Wilder, Eliza Jane's niece and daughter of Almanzo and Laura Ingalls Wilder, probably lived in this home in 1904 while she attended Crowley High. The home was later demolished.

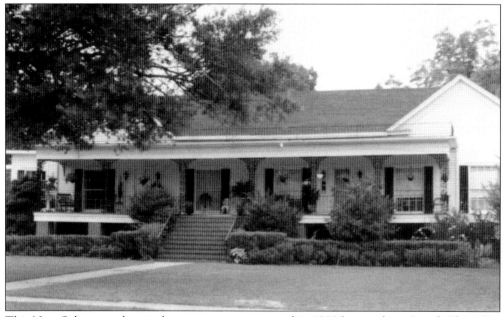

This New Orleans–style raised cottage was constructed in 1890 by merchant Joseph Blum. His spouse was Emma Lichtinstein. Other owners included Edwina Rogers, widow of Jube Rogers, and her sister Lucille Rogers (Mrs. Sidney) Foster. Larry Parrot (1908–1987) and his spouse, Edrie (1906–1989), purchased the home in 1938. Later, their daughter Jo-Anne and her husband, Richard Arnand, moved into the house.

Seven
PEOPLE

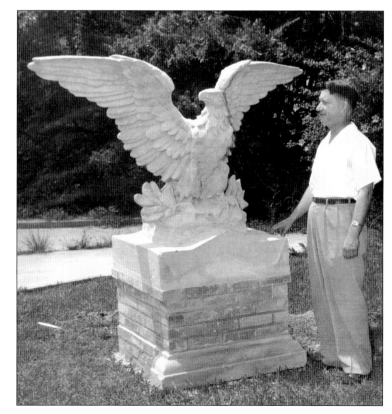

Rev. Paul Butterfield Freeland (1904–1976) is shown on June 14, 1950, with the sculptured eagle that was atop the second courthouse. A noted genealogist and Crowley historian, he authored *The First Presbyterian Church of Crowley, La., 1890–1965* and coauthored *Acadia Parish, Louisiana: A History to 1900* with Mary Alice Fontenot. His collection of Crowley photographs and memorabilia is deposited in the Acadia Parish Library.

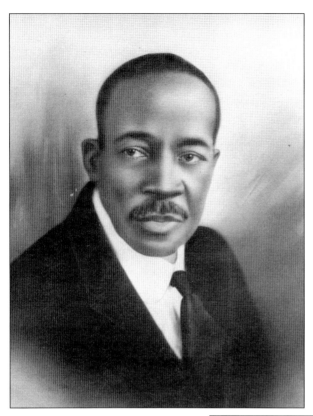

Crowley had two highly respected early educators. Henry Clay Ross (1871–1945), at left, arrived in Crowley in 1899 and was involved with the education of African Americans until his retirement in 1942. He brought Booker T. Washington to Crowley in 1915. A charter member of the People's Investment Company in 1902, Ross also served as pastor of Morning Star Baptist Church from 1910 until his death. He had a street, a high school, and an elementary school named for him. He and his wife, Louise, had two children. Seen below, James "Jack" Mobley served as principal of Crowley High from 1916 until his death. Although he and his wife, Blanche, had no children of their own, Jack (1880–1937) was remembered for devoting his life to the education of Crowley's children. Crowley's walking track, Mobley Park, is named in his honor.

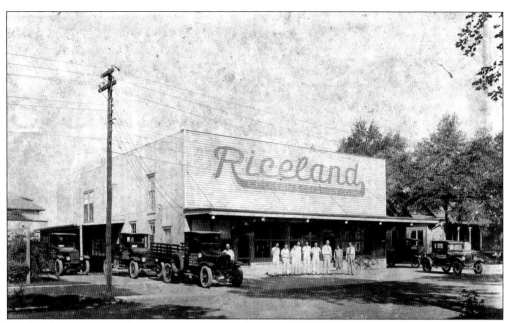

Riceland Ice Cream and Creamery, seen here about 1929, was located at the corner of Third Street and Avenue F. The workers standing in front of the store are, from left to right, Gilbert Herpin (next to car), Paul Cart, Clifford Herpin, Leo "Hitchey" Perkins, unidentified, John Dupre, Clyde Horn, G.W. Butcher, Cecil Embry, and Albert F. Horn Sr.

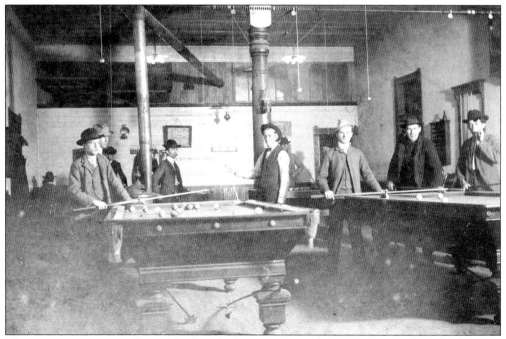

This is an interior view of Lynn J. Perkins Pool Room in an unknown location. The only identified person is Perkins, standing fourth from the left. He moved to Monroe, Louisiana, in 1931.

Glady Printing, which occupied a part of the Crowley House building after World War II, was forced to move when the building was condemned in 1972. Proprietors Glady and Mary Trahan (front left) pose as the Linotype machine is being moved to a new location on Avenue F. The company remained in business until 2006. (Courtesy of the *Crowley Signal*.)

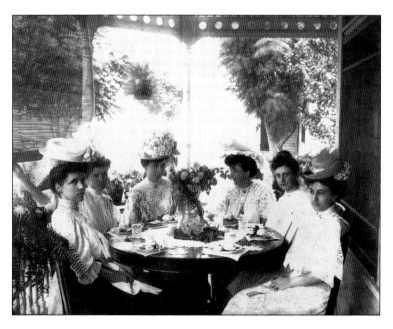

This photograph shows a group of women at a social gathering. They are, from left to right, Ova Lawrence Ledbetter, Mary Lou Joplin Edmundson, Mamie Duson Lawrence, Eula Clark Coleman, Mable Knight, and Lola Duson, the daughter of C.C. Duson. (Courtesy of Lee Lawrence.)

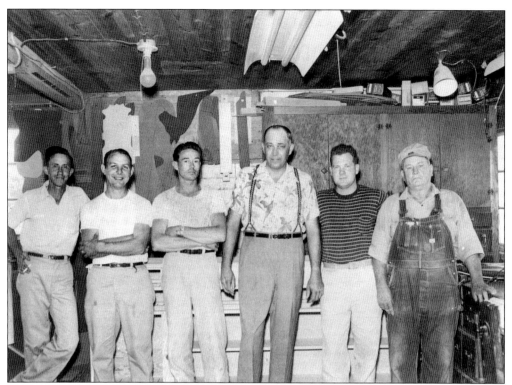

Herbert Sudwischer operated a furniture manufacturing business just north of town. Here, he and several employees pose in his workshop, where ranch-style furniture was made. Shown are, from left to right, Eddie Schexnider, Cliff Franke, Eulice Nolan, Sudwischer, unidentified, and Otis Kibodeaux. Sudwischer operated this business from the mid-1950s until the late 1960s. (Courtesy of Larry Franke.)

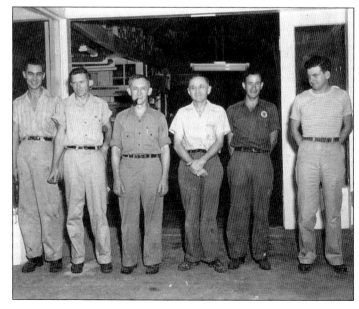

Acadia Battery Station opened for business in 1916 under proprietors Gary (1897–1962) and Stanley Bergeron (1902–1970). Pioneers in the field, they sold and repaired storage batteries. They later sold automobile parts and did lawn mower repairs. Posing in 1949 at the establishment on East Fourth Street are, from left to right, Henry Capel, Gerald Pullin, Otto Weger, Stanley Bergeron, Lawrence Forman, and Morris Guidry Jr. It closed in 1987.

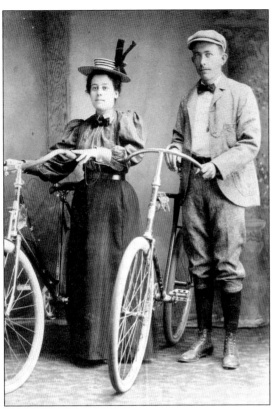

William E. Lawson (1868–1936) and his wife, Susan Neelis (1869–1950), pose with their new bicycles. They came to Crowley in 1893, when he partnered with J.A. Sabatier in a general store. Later, Lawson had interests in banking and rice farming. Although they had no children, his wife was presented with the Daily News Loving Cup by the Crowley Progressive Union in 1903 for her charitable work with children.

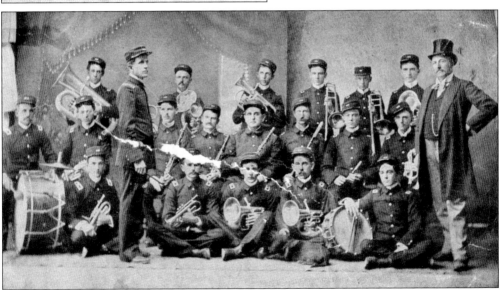

The Crowley Band was organized in 1888. Members of the band are seen here in 1900 in their dark red broadcloth uniforms. Standing in front, at left, is conductor Ulysses Scarborough. Standing at right is band promoter Charles L. Crippen. The identified musicians are (first row) Med Marshall (far right); (second row) Henry Taylor (second from left), Louis White (second from right), and Lynn Perkins (far right); (third row) Robert White (far left), Jay Freeland (third from left), Lester Lyons (fourth from left), and Claude Campbell (far right).

Above, the Cotton Blossom Minstrels, a group of mostly Crowley boys, performed at the Grand Opera House on April 23, 1914, to benefit the Crowley Fire Department. The program consisted of singing, dancing, and comedy. It was reported to be "one of the best ever" shows at the Grand. Posing are, from left to right, (first row) Eddie Hollins, Camille Sureau, August Da Costa, Leslie Israel (producer), Claude Singleton, Clarence Boudreaux, and Frank Youse; (second row) Bob Kleiser, Carl Meyer, R.J. Boudreaux Jr., Willie Harmon, Erwin "Boobus" Andrews, I.H. "Dutch" Oertling, Lawrence Martin, Forrest Buckley, and Nick Morrow; (third row) Harvey Dow, Raymond Wilson, Mike Griffin, Charlie Hoag, Bernard Meaux, Robert White, Ed Dannerer, ? Ferguson, and Boyd Milton. Below, the 1921 senior class of Crowley High attends the Grand Opera House on May 23, 1921.

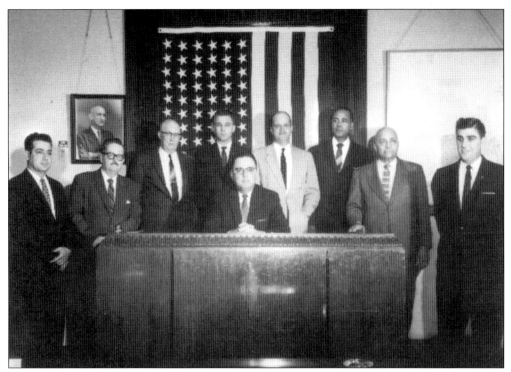

The Crowley City Council is seen here in 1958. Mayor Joseph Gielen is seated at center. Those standing are, from left to right, Henry Helo, Emile A. Carmouche, Medrick Morgan, Edwin Edwards, Charles T. Everett, Joseph Pete, David May, and Howard Duncan. Pete (1912–2005) and May (1899–1987) were first elected to the city council (Ward 3) in 1954. They were Louisiana's first African American councilmen since Reconstruction. Pete served from 1954 to 1982 and May from 1954 to 1962.

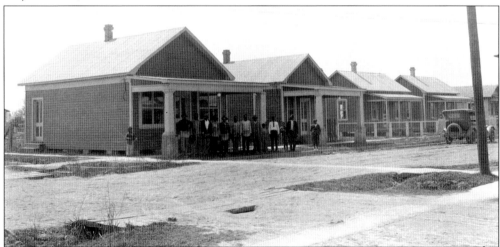

In 1925, members of the African American community pose in front of a general store, located at Avenue C and West Third Street, and a row of houses owned by Marcel Thomas (1864–1963), a black businessman. A real estate agent, Thomas purchased his first property in Crowley in 1897. He was a charter member of the People's Investment Company and served as treasurer. The corporation, which formed in 1902, continues to operate.

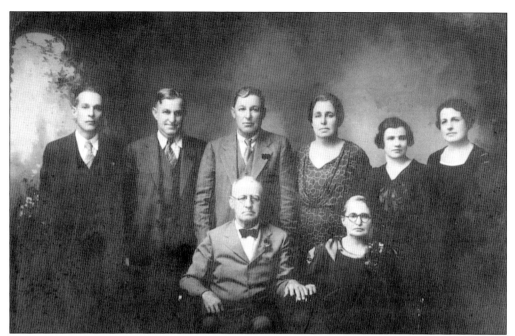

Pioneer residents of Crowley since 1902, Ovignac Dore (1864–1951) and Josephine Stelley Dore (1861–1946) are shown here (seated) celebrating their 50th wedding anniversary in 1934 with their children. The siblings are, standing from left to right, Joseph (1892–1973), Judge Hugo (1891–1953), A.B. Sr. (1884–1965), Natalie (Mrs. O.T. McBride; 1886–1951), Louise (Mrs. Odilon Abshire; 1889–1947), and Erin (Mrs. Denis Canan Jr.; 1895–1981). Joseph was the owner of Supreme Rice Mill. A.B. Sr. owned Dore Rice Mill. Erin was an Acadia Parish home demonstration agent. (Courtesy of Elliot Dore.)

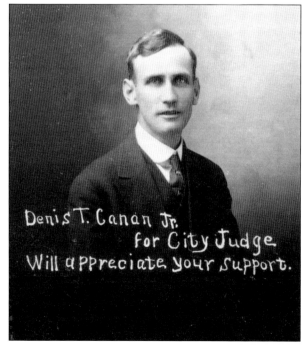

Denis Timothy Canan Jr. (1884–1950) is shown on a campaign card in his election bid for Crowley city judge. One of the longest-tenured judges in Louisiana, he served from 1912 to 1950. After receiving his law degree from Tulane University, he practiced in Crowley for two years before overwhelmingly winning his first election as city judge. He married Erin Dore in 1921; they had no children.

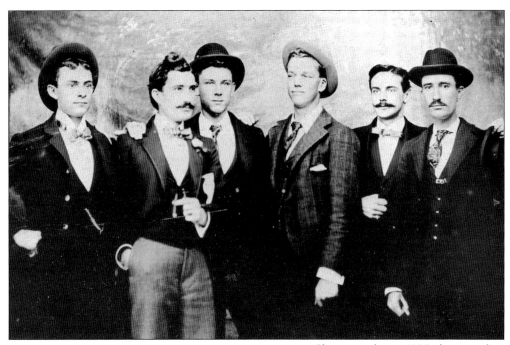

Shown in this c. 1900 photograph are, from left to right, Cliff Guidry (1874–1902), barber; Dan Egan (1871–1957), department store owner; Lester Lyons (died in 1919 in San Antonio); Curt Lyons (1876–1932), rice buyer; William Hollins (died in 1957 in Baton Rouge), jeweler; and William Egan (1868–1928), Crowley mayor.

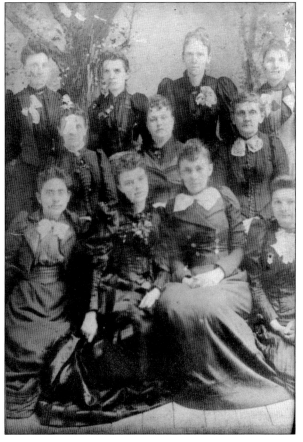

Posing about 1890 are, from left to right, (front row) Ella Robinson (Mrs. Brisco) Carter, Catherine Pickett (Mrs. Charles) Crippen, Clara Thayer (Mrs. W.W.) Duson, and Grace Botsford; (second row) Irene Dodge, Mary Mensur (Mrs. Squire) Pickett, and Sarah Ann Fernald (Mrs. Henry) Thayer; (third row) Lucetta Thayer (Mrs. Cyrus) Cornwell, Martha Thayer (Mrs. John) Robinson, Ella Crippen (Mrs. Will) Robinson, and an unidentified woman. All were from Minnesota and related by blood or marriage.

The Crowley Women's Club was begun in 1901. The members posing above in 1905 are, from left to right, (first row) Mary Frances (Mrs. Howard) Brooks, Anna (Mrs. Laurent) Bliss, Leola (Mrs. John) Nixon, Flora (Mrs. O.R.) Hopson, Ida (Mrs. Homer) Chachere, Etta Thomas, and Mrs. Kate Lyons; (second row) Mrs. S.R. Silvernail, Catherine (Mrs. Benjamin) Carper, Phoebe (Mrs. Preston) Lovell, Frances (Mrs. George) Fraser, Ruth (Mrs. W.E.) Ellis, Carrie (Mrs. J.D.) Marks, and Kate (Mrs. Hampden) Story; (third row) Mrs. Caldwell, Mrs. Wilson, Mrs. Emer Foley, Mrs. Schultz, Olive (Mrs. J.B.) Foley (first president), May (Mrs. Herbert) Ellis, Ida (Mrs. John) Naftel, Daisy White, and Mrs. Wilsy. Below, Leona Faulk (Mrs. Raney) Richard sits in a Dusenberg automobile about 1920. Her husband operated a gunsmith/garage south of Crowley. In the background of this photograph, taken by B.A. Barnett, is the Frankel home, across the street from Barnett's studio.

In October 1930, American Legion Post 15 formed a committee—composed of Charles Macholl, E. Dorsey Peckham, and Malcolm McCorkle—to organize a drum-and-bugle corps. By March 1931, the group had formed. The members' uniforms consisted of belted blue jackets and white pants. They performed in parades, as well as at conventions and other events. Posing here are, from left to right, (first row) Webster Bachelot, Elzy Stutes, Dewey Stutes, Teddy Hoffpauir, J.A. Boggs, Henry Fisher, Dave Wilder, Dr. H.L. Gardiner, Robert Schlicher, Dorsey Peckham, R.

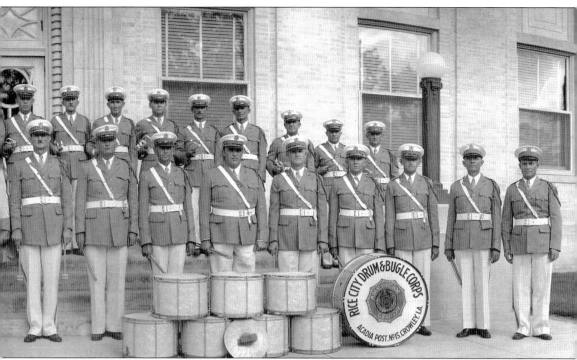

Cruise, Jim Thompson, Roy Roller, John Foret, Victor Hoag, Many Bergeron, Charles Macholl, Paul Letz, and Elmer Trumps; (second row) John Jefferson, Colbert Guidry, Anthony Manuel, Cecil Roberts, Walter Simon, Dr. E.M. Lafitte, Matt Buatt, E.P. Richard, A.B. Core, George Rollosson, Raymond Wilson, Vincent Daigle, George Robichaux, Erwin Andrus, Gilbert Broussard, Nick Broussard, Percy Blum, Leonce Jumonville, and Isaac "Ike" Broussard.

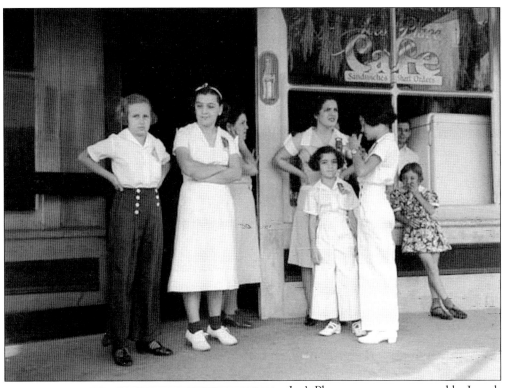

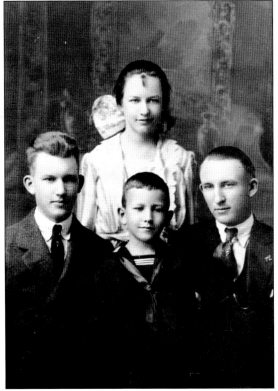

Joe's Place, a restaurant owned by Joseph (1900–1974) and Sarah (1907–1988) Scalco, operated on Parkerson Avenue from 1932 until Joseph's retirement in 1968. Family members and friends shown here are, from left to right, Gloria Savoy, Sarah Lusco Grado, Sarah Scalco, Lucille Pizzolato Kober, Rosalie Scalco Landry, Amelia Scalco Meaux, Joe Scalco, and Gloria Lusco Faulk. (Courtesy of Rosalie Scalco Landry.)

Charles J. (1864–1949) and Almyra (1874–1947) Freeland were early Crowley pioneers. Almyra's brother-in-law was Crowley banker W.E. Ellis. The couple's children pose in this photograph. The sons are, from left to right, Paul (1904–1976), Charles Jr. (1915–1972), and Barton Woodward Sr. (1902–1997). Daughter Ethel (1908–1997), in back, married Rev. Henry Darden. Rev. Paul Freeland is remembered as Crowley's historian. Charles and Barton engaged in banking, rice farming, and irrigation businesses. All were active members of the Presbyterian Church.

Eight
Sports

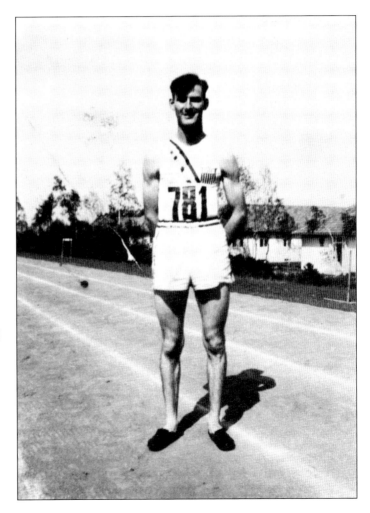

Dudley Wilkins (1914–1989), perhaps Crowley's most honored athlete, participated in the 1936 Berlin Olympics. Active in football, baseball, and track at Crowley High, he qualified for the Olympics, where he placed eighth in the hop, step, and jump, with a leap of 48 feet and 3/8 inches, behind Japan's Naoto Tajima. A juvenile officer for the Crowley Police Department, his spouse was Acadia Parish's first librarian, Virginia McDonald (1914–1985).

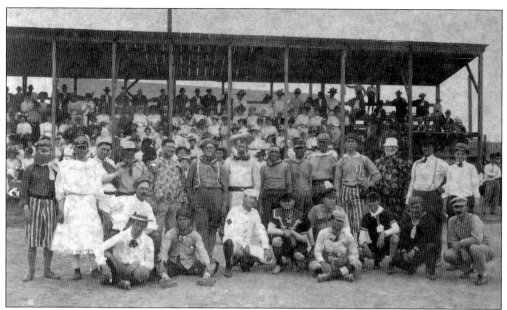

The photograph above depicts Crowley's lawyers and doctors/pharmacists in costume as they played a benefit baseball game on May 3, 1908, to raise funds for Amite tornado victims. The medical team won 17-9. The players are, from left to right, (seated in front) Dr. Felix Guilbeau; (first row) Dr. S. Pulliam, Dr. Ralph Raney (kneeling behind Pulliam), Dr. Zachary Francez, Paul Eckels, Dr. Manasseh Hoffpauer, Dr. John Copes, Dr. Elijah Ellis, Dr. H. Cockerham, and ? Scott; (second row) Percy Ogden, Dr. Thomas M. Toler, John Robira, Percy Holt, Joseph Medlenka, Shelby Taylor, Philip Pugh, Howard Bruner, Abbie Chappuis, Hampden Story, James Dorman, Philip Chappuis, Thomas J. Toler, and Joe Dennis. Below, in 1906, Crowley's baseball team attracted 400 spectators to one of its games. The players are, from left to right, (first row) Braney Turner, Newt Kershaw, Riley Boudreaux, Frank Guidry, and Willie Pique; (second row) Frank Kitchens, Charles Whitney, manager Robert Jordan, and George Abbott; (third row) Ed Sereau, Hardy Hebert, John Castille, Louie Barry, and Sam Facundus.

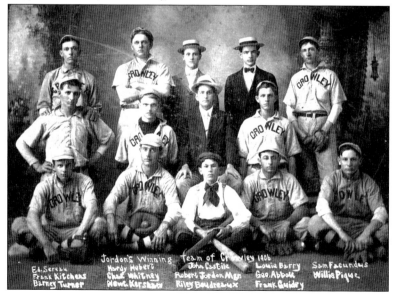

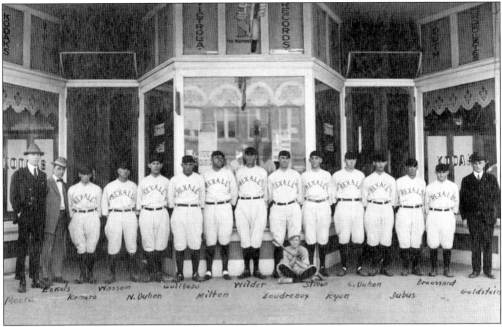

The Rexall baseball club of Crowley, in existence in the 1920s, played home games at DeBellvue Park in South Crowley. The 1922 roster featured, from left to right, ? Moore, manager Paul Eckels, A. Romero, Mickey Wassem, N. Duhon, Paul Guilbeau, ? Milton, Dave Wilder, Riley Boudreaux, Walter Simon, Rosie Ryan, Claude Duhon, Wilton Dubus, Isaac "Ike" Broussard, and general manager Phil Goldstein. Seated in front is batboy Roy Bourque.

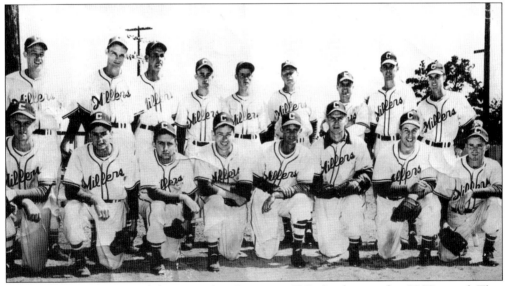

The Crowley Millers joined the Evangeline League in 1951, finishing with a 70-70 record. That year, the total attendance at Miller Stadium was 100,595. Shown here are, from left to right, (first row) Johnny Pfeiffer, Jerry Simon, Jack Balzli, John Petrick, manager Johnny George, pitcher Oscar Johnson, Ray Smerek, and Kelly Lunn; (second row) Walk Lamey, Robert Hovell, pitcher Ray Hensgens, Amilca Fontenot, Vernon Wade, Lincoln Fowler, Bill Turk, Alton Sawyer, and pitcher Chick Morgan.

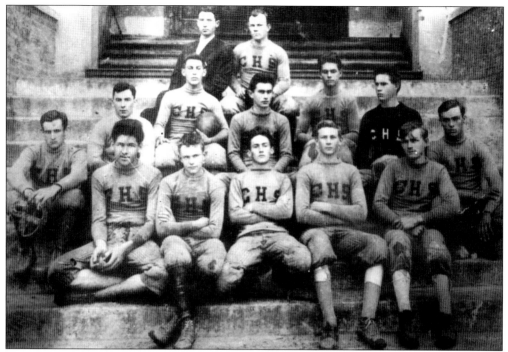

The Crowley High football team of 1913 had six victories, including a 7-0 win over Southwestern Louisiana Institute's freshman team (future University of Louisiana at Lafayette); the team had just two losses that year. Pictured here are, from left to right, (first row) Bob Schlicher, George Lovell, Eric Smith, Morgan Irving, and Ray Hoag; (second row) Isaac "Ike" Broussard, Henry Fontenot, Norris Duhon, Clarence Martin, Ed Cassidy, Ernest Ellis, and Jesse Hoffpauir; (third row) coach Alan Smith and Seeley Hoyt.

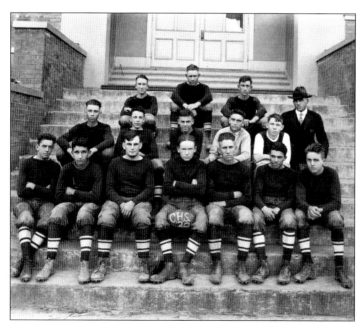

The Crowley High football team poses on October 28, 1920. The team had a 1-3-1 record that year. Pictured here are, from left to right, (first row) Frank White, Leo Ringuet, Frank Cuplin, Austin Milner, Clement Foreman, Bennie Andrepont, and Claude Hoffpauir; (second row) James Wilder, Belton Fontenot, Kenneth Toler, Alton Reynaud, Oscar Joffrion, and coach W.G. Readhimer; (third row) Barton Freeland, Burton Merritt, and Emmitt "Dick" Merritt.

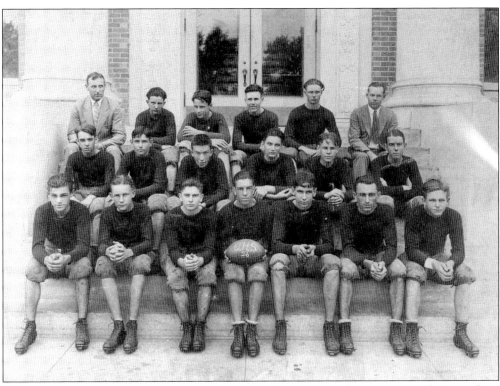

In 1926, the Crowley High football team finished the season with a 3-4-2 record. Posing here are, from left to right, (first row) Vic Barousse, Elwood "Sonny" Harkins, Elmer Gaudet, Joe "Crip" Voorhies, Allen Fontenot, Jack Lawrence, and Russell Hayes; (second row) Sap Dubus, Jack Cart, Fernan Marx, Ben Goldstein, Frank Hill, and Winston "Soapy" Terrell; (third row) principal Jack Mobley, Charles Bollich, Lou Williams, Kenneth Stutes, Percy "Goofy" Bertrand, and coach Frank Smith.

The Crowley High football team had a 5-3-1 record in 1928. The players are, from left to right, (first row) Jack Lawrence, Thomas Davies, Jerome Breaux, Price Barbour (all-state), Percy Bertrand, Earl Coles, and Jack Cart; (second row) Louis Toler, Henry Dupre, Fernan Marx, Elwood "Sonny" Harkins, Harry Breaux, and Matthew Hanagriff; (third row) James Gremillion, Lloyd Villeret, Lawrence "Boo" Amy, and Charles Bollich.

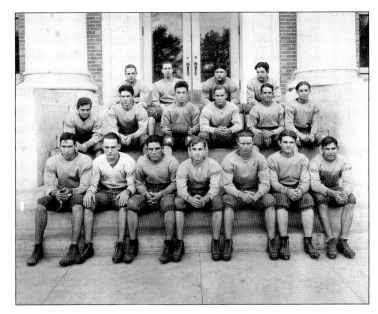

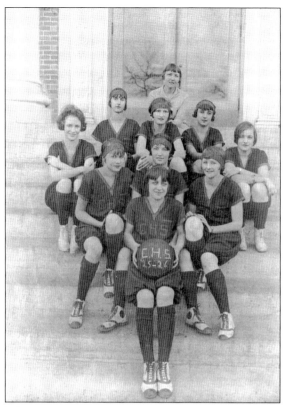

The photograph at left shows the Crowley High School girls' basketball team of 1925–1926. Only six members are mentioned in newspaper articles. Forward Viola Bier (Mrs. John Blessen) is in the second row, far right. Also playing forward was Bernice Gueno. The guards were Maxine Smith and Nora Mae Miles (Mrs. George Cantey), holding the basketball. The running center was Grace LeBlanc, and the jumping center is Marian "Mazie" Lewis (Mrs. Robert Broadhurst), in the third row, second from left. Miles was the captain. At that time, girls played six on six. The aerial photograph below, taken in 1922, shows a portion (lower right) of the Acadia Parish Fairgrounds. Built in 1907, the 30-acre site was located just south of Bayou Blanc. The grandstand held 800 spectators. The half-mile track featured horse, trotting, pony, and harness racing. The fairgrounds were also used for baseball games and Fourth of July celebrations. Fairs were held until at least 1915.

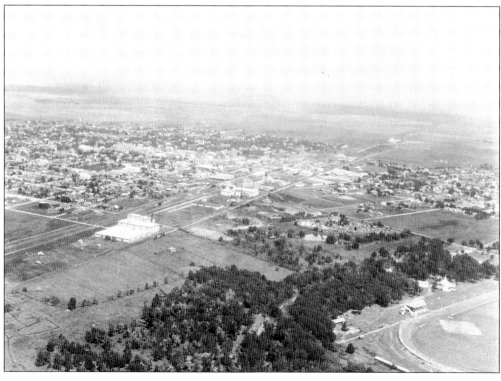

Nine
MISCELLANEOUS

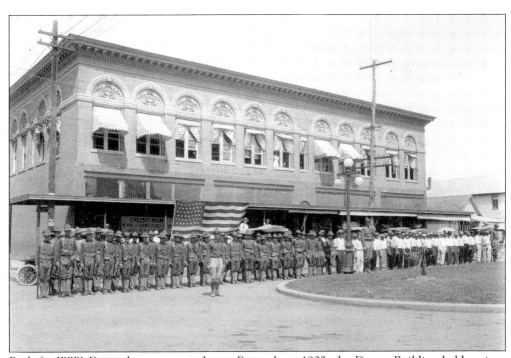

Built for W.W. Duson by contractor James Petty about 1902, the Duson Building held various offices. This photograph, taken on Sunday, June 24, 1916, records the assembly of National Guard Company B in preparation for its departure to Camp Stafford in Alexandria for service in World War I. Led by Capt. Friend Quereau, the group marched to the depot with hundreds of patriotic citizens and the Crowley Concert Band.

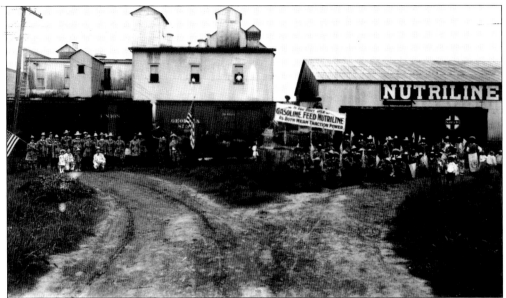

The Nutriline Milling Company manufactured Nutriline, a steam-cooked commercial feed for livestock, as well as Momylk, a feed for dairy cows. Rated by the Louisiana State Board of Agriculture as some of the best manufactured commercial feeds, these were distributed by the Lawrence Brothers Company. The company was organized in 1904 and operated for about 15 years. P.L. Lawrence served as president. A large manufacturing plant, built in 1904, was located on West First Street. The photograph above shows workers dressed for a Fourth of July parade in 1912. At left, the uniforms are seen up close on P.L. Lawrence Sr. and Jr. (At left, courtesy of Lee Lawrence.)

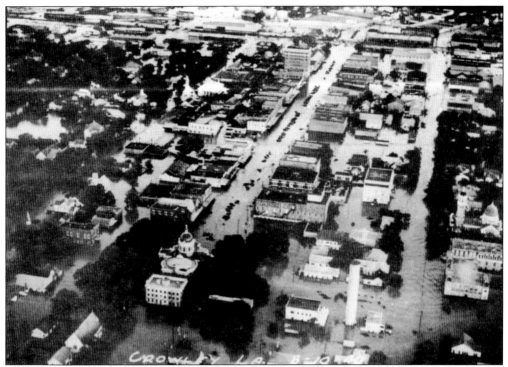

As a category-one hurricane in the Gulf of Mexico moved inland on August 7, 1940, torrential rains dropped 30 inches in four days, including 20 inches in a 24-hour period. Because of an extremely rainy summer, already-full streams and soaked grounds were unable to tolerate more rain. The high-water mark was eight feet in some areas. The National Guard and Coast Guard helped thousands evacuate to other cities. Fortunately, no one drowned, and the water finally receded after six days. Tons of lime were used to lessen the odor of decay. The photograph above shows the downtown area, where all businesses were inundated with about four feet of water. The second stories of businesses were opened for employees and their families. Shown below are First National Bank and a stranded automobile. (Above, courtesy of the *Crowley Signal*.)

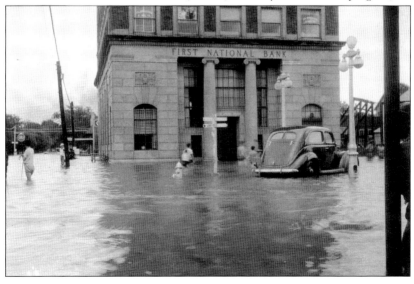

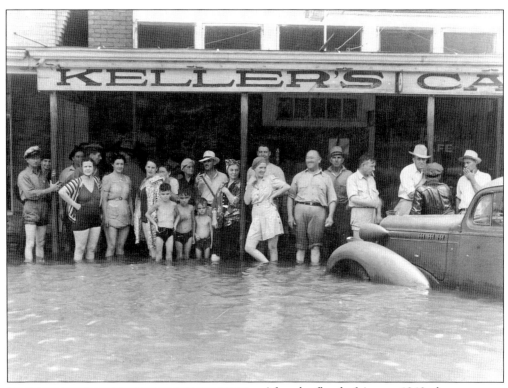

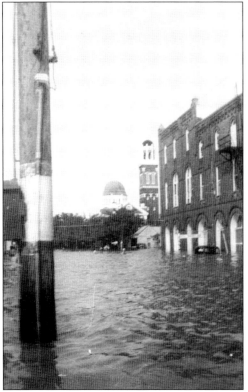

After the flood of August 1940, the group seen above congregates in front of Keller's Café, located on Parkerson Avenue between First and Second Streets. For years, it was open 24 hours a day. Noted for its hamburgers, a customer could get a burger and a cup of hot coffee for 30¢. It was a popular place for Crowley policemen. Proprietor Rudolph Keller is sixth from the right. The photograph at left shows a flooded Fifth Street. St. Michael's Catholic Church is in the background, and the side of the Grand Opera House is in the foreground.

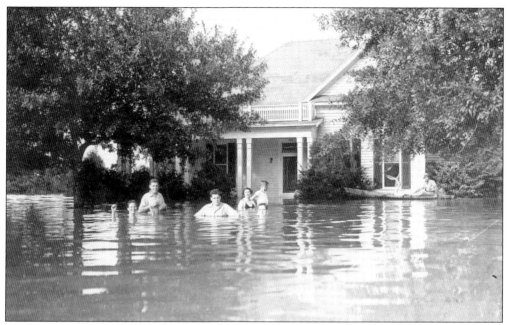

As a result of the flood, water entered 80 percent of Crowley homes. There was no electricity or sewerage; food and medical supplies came by rail and were distributed to those in need. It took several weeks before Crowley returned to some form of normalcy. Dr. Edward Stanley Peterman's home on Eastern Avenue is seen above. Dr. Peterman (1895–1965) was a surgeon who began his practice in Crowley in 1919. He worked tirelessly during this time of crisis in his community, even riding horseback to make house calls to administer typhoid shots. The photograph below shows Dan J. Feitel's home on East Third Street. Feitel (1887–1968) was involved in the rice industry, especially milling and irrigation. Feitel is seen here with his niece Hazel Kollitz.

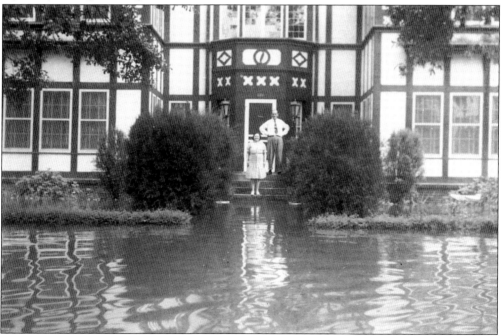

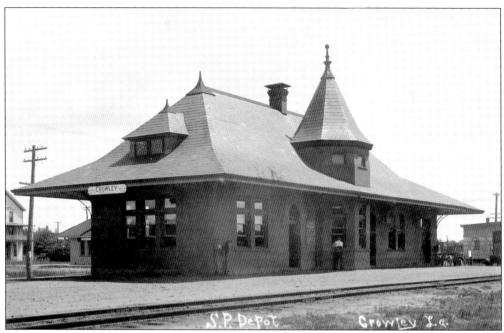

Built in 1902 on the east side of Parkerson Avenue, the fourth Southern Pacific depot (above) was demolished in 1987. Crowley's first depot, moved from Estherwood in 1887, and the second, larger one, which burned down in 1894, were located in the center of Parkerson Avenue. Erected in 1894 on the west side of the avenue, the third depot (below) serviced both passengers and freight. Railroad laborers, among many of Crowley's first residents, are shown in this undated photograph. The depot was demolished in 1972.

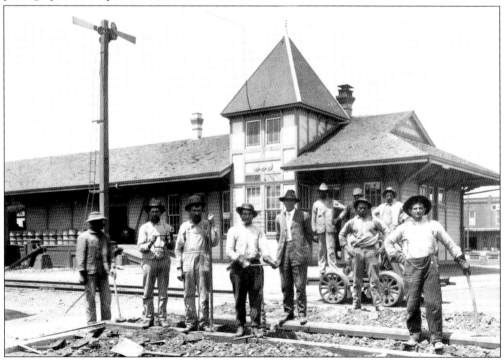

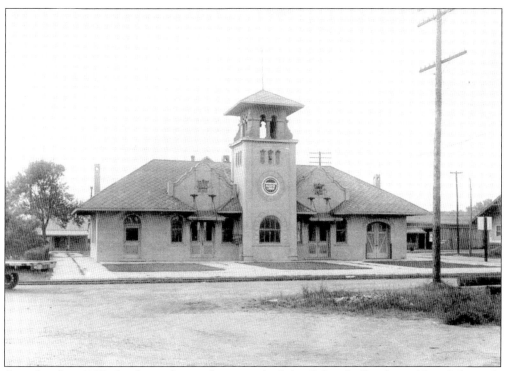

Completed in 1907, the depot shown above was built by Colorado Southern, New Orleans & Pacific. The new owner, Frisco Railroad, took possession when it opened. Designed in the Mission style by Austin architect C.H. Page, it was incorporated into the Gulf Coast Line in 1915. Later, it was used by Missouri Pacific. It was home to the American Legion from 1934 to 1945, and the Crowley Chamber of Commerce had its office here for a time. Entered in the National Register of Historic Places in 1980, the depot was home to Louisiana Church Interiors before being donated back to the city in 1986. Below, a train with flatcars loaded with tractors arrives at the Southern Pacific depot in the 1930s. Although no further information accompanies this photograph, it is assumed that many of those awaiting the train are farmers.

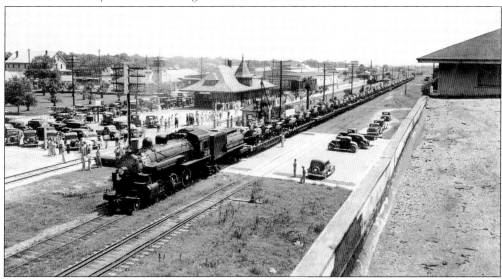

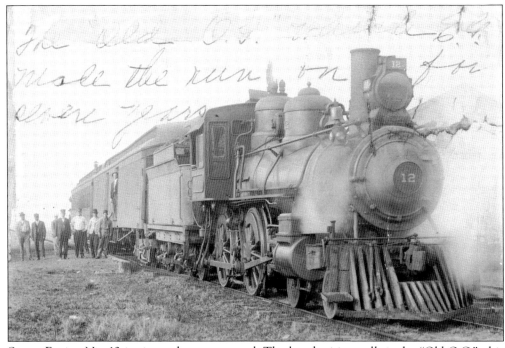

Steam Engine No. 12 is pictured on a postcard. The handwriting calls it the "Old O.G."; this probably refers to the Opelousas Gulf Railroad. Although no other information is available, the train is probably typical of the steam engines that made stops in Crowley.

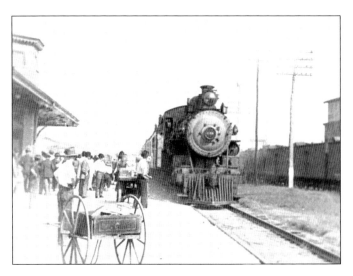

A crowd awaits an incoming train. Railroads were a vital transportation method in early Crowley. Besides bringing in many new residents and visitors, there were excursion trips to New Orleans and Houston. Trains evacuated many Crowleyites to higher ground in Lafayette during the flood of 1940 and brought in many refugees from the flood of 1927. Visitors to Crowley, such as Babe Ruth and Booker T. Washington, arrived by railroad.

On Saturday, October 16, 1909, Parkerson Avenue was filled with animals and performers of the Carl Hagenbeck Animal Show and the Great Wallace Show as they paraded in Crowley. A newspaper advertisement boasted of 1,000 employees, 400 horses, and 300 performers, including 50 clowns and 75 musicians.

Crowley held parades on Armistice Day, which commemorated the peace treaty signed to end World War I on November 11, 1918. The 1920 parade is seen here on Parkerson Avenue. Note the palms planted in the neutral grounds. Other highlights of the day included a concert by 30 members of the Louisiana State University band and a football game between Crowley High and St. Charles of Grand Coteau.

Crowley held its first Rice Carnival in 1927, with Sol Wright and his daughter Edith reigning as King and Queen Rice. On November 12, 1928, a second and final Rice Carnival took place in conjunction with Armistice Day activities. Shown here on their float are King Rice II, Mayor Gordon Brunson (1900–1931), and Queen Rice II, Margaret Francez (1905–2003), who was the daughter of coroner Dr. Zachary Francez.

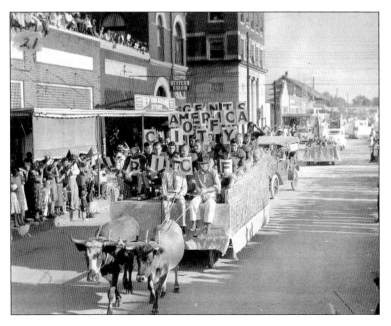

Crowley celebrated the 50th anniversary of its founding on October 5, 1937, by honoring its founders, the Duson brothers. The city decided to hold a rice festival on the same day. The festival was cochaired by Bob Schlicher and Justin Wilson. Highlights of the parade that day included the LSU band and the Crowley High football team, shown here riding a float led by a pair of oxen.

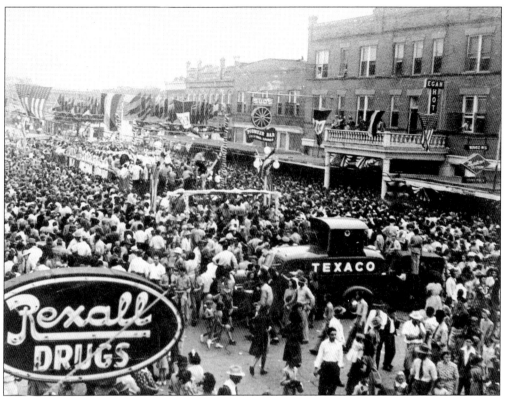

The first National Rice Festival was held on October 5, 1937. Rice festivals were held from 1938 through 1941. Cancelled during World War II, the festival was again held on October 17–18, 1946. In recognition of the worldwide importance of rice, its name was changed to the International Rice Festival. This photograph shows the main platform at the Egan Hotel. The platform would later be moved to the courthouse grounds.

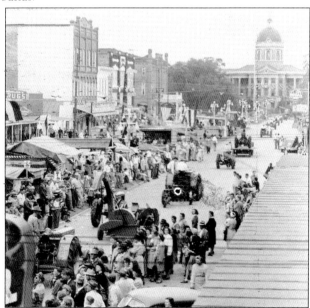

This farm-implement parade was part of the 1948 International Rice Festival, held on November 4–5. The parade, showcasing farm equipment, was a part of the festival for many years.

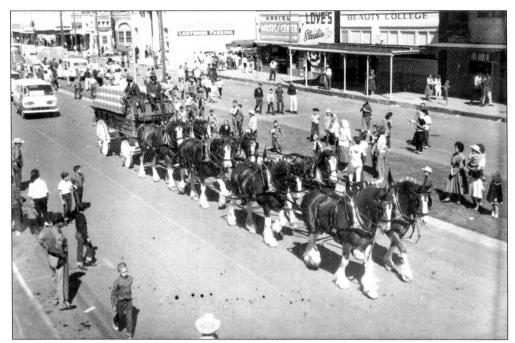

The Anheuser-Busch Clydesdales are always a crowd favorite at the rice festival. Although this photograph is from a later visit, their first appearance was at the second rice festival in 1938.

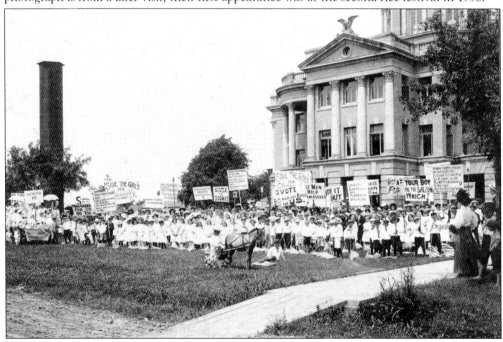

The Women's Prohibition Club sponsored a children's parade. This photograph, taken on April 21, 1908, shows children on the courthouse grounds. The anti-Prohibition faction noted that rice farmers would suffer some loss of revenue since a percentage of the rice crop was shipped to brewers. Acadia Parish voters passed Prohibition by a majority of 244; however, in November 1910, voters repealed Prohibition by a majority of 303.

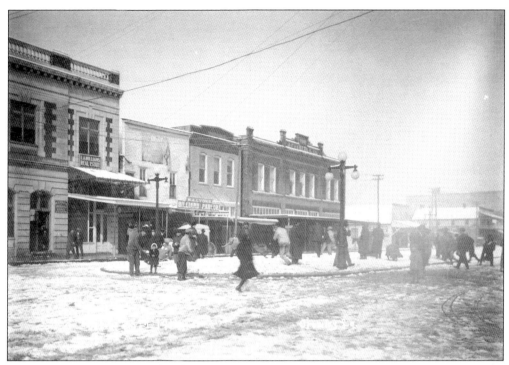

Crowley citizens awoke to a blanket of snow on the ground on February 25, 1914. During the preceding night, with below-freezing temperatures, a drizzling rain developed into sleet. In the early-morning hours, four inches of snow fell. The snow provided great entertainment for children and adults alike. The newspaper reported several snowball fights. This photograph captures some of the frolicking fun on Parkerson Avenue.

The Liberty Bell made a 10-minute stop in Crowley on November 19, 1915, on its return journey to Philadelphia from San Francisco, where it was on display as part of the Panama-Pacific International Exposition to celebrate the opening of the Panama Canal. Hundreds of Crowley's citizens were able to view the bell, which was mounted on an open railcar upon an elevated frame.

Although the Crowley Lodge of the Odd Fellows was organized in 1895, the home was not built until 1910. This 1913 photograph shows a number of orphans, who represented the majority of residents at the home until the 1930s. The home's residents raised chickens and grew their own produce. It was torn down in the 1960s, and a one-story building was erected in 1969. It closed in 2013.

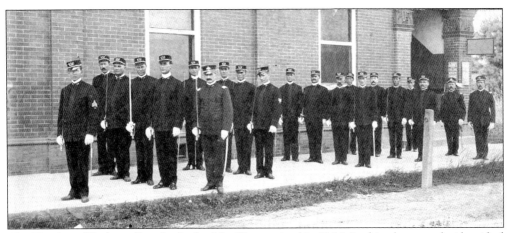

The Knights of Pythias, Crowley Lodge No. 85 organized in 1906. In this photograph, identified members are William A. Snyder (far left), Joseph Roller (third from left), W.T. Burt (fifth from left), Phil Goldstein, captain (seventh from left), Clem Anderson (eighth from left), and Charles Finley (third from right). The Knights sponsored the Fourth of July activities in 1908.

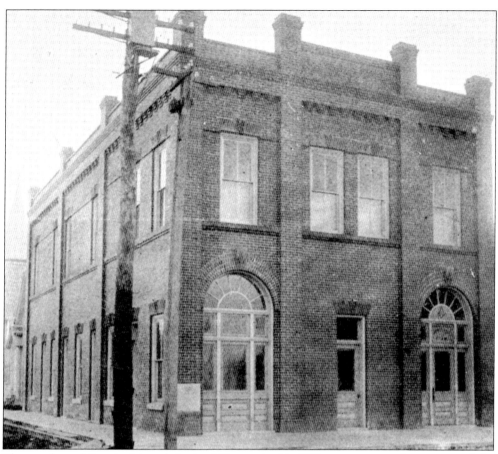

The members of Crowley Masonic Lodge 243, organized in 1892, met at various locations until the Masonic temple seen above was built in 1902 on land donated by W.W. Duson at the corner of East Hutchinson Avenue and the Court Circle. The photograph below, taken by E.K. Sturdevant, shows the Crowley and visiting Welsh members on December 27, 1895. They are, from left to right, (first row) William Russell, Jac Frankel, J. Vallient, Dr. John Casper, L.O. Hills, Lee Robinson, O. Fulton, Colbert Foreman, Andrus Shaw, Henry Thayer, Abrom Kaplan, and W.S. Coleman; (second row) unidentified, John Burgin, Felix Schmulen, Charles Martin, John Cooper, Ezra V. Rudrow, and Eldridge Lyons; (third row) Dr. N. Bascom Morris, Theodore Schaedel, Prof. J. Barrett, S.B. McElhinney, Henry Wiley, unidentified, W. J. McElroy, Zadock Mayes, Dr. James Morris, and J.L. Thiel.

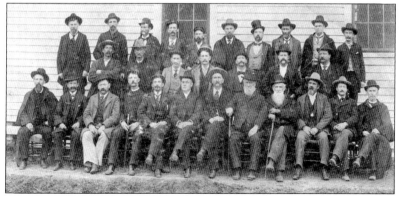

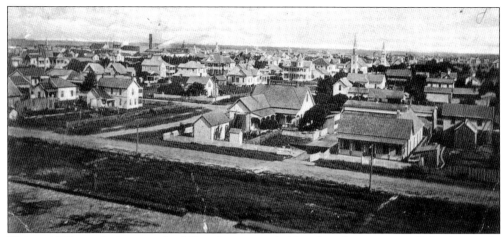

This c. 1902 aerial photograph of Crowley was probably taken from a rice mill. In the north-facing view, Front Street is the closest street; the side street to the left is North Avenue I. Identifiable in the photograph are two large residences on Second Street: W.L. Trimble's home (center) and R.T. Clark's home (left of center). The church in the right foreground is the original Methodist church.

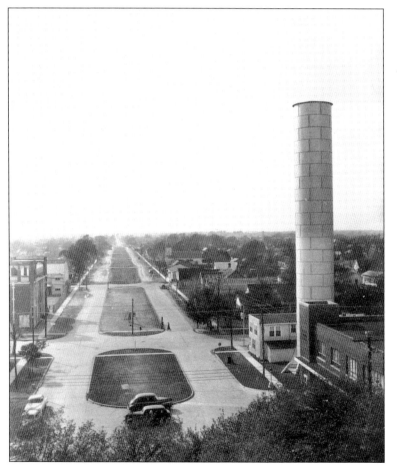

This photograph of West Hutchinson Avenue, taken in the early 1950s, shows the current fire station, built in 1949, at the lower right. The old fire station was moved partially into the street while the new one was constructed. The standpipe, which held the water, was demolished in 1973. Just visible on the left is St. Michael's School.

Although this photograph was taken in the 1930s, it shows a mixture of historic and modern Crowley. The building in the right forefront is the Crowley House, erected in 1887 at Crowley's founding. It served Crowley for over 80 years until it was demolished in 1972. The tall building is the First National Bank, constructed in 1921. It continues to be a vital part of the community. The contrast between an old frame building that welcomed Crowley's first residents and a seven-story bank building that continues to serve those first residents' descendants represents the best that Crowley has to offer. The affinity between Crowley's history and present continues to thrive. Crowleyites embrace their past and look forward to developing more improvements. Crowley's founder, W.W. Duson, would be proud of "his" town.

Discover Thousands of Local History Books Featuring Millions of Vintage Images

Arcadia Publishing, the leading local history publisher in the United States, is committed to making history accessible and meaningful through publishing books that celebrate and preserve the heritage of America's people and places.

Find more books like this at
www.arcadiapublishing.com

Search for your hometown history, your old stomping grounds, and even your favorite sports team.

Consistent with our mission to preserve history on a local level, this book was printed in South Carolina on American-made paper and manufactured entirely in the United States. Products carrying the accredited Forest Stewardship Council (FSC) label are printed on 100 percent FSC-certified paper.